THE ONION MAGAZINE
THE ICONIC COVERS THAT TRANSFORMED AN UNDESERVING WORLD

ALSO BY *THE ONION*

The Onion Magazine

THE ICONIC COVERS

THAT TRANSFORMED AN UNDESERVING WORLD

L B

LITTLE, BROWN AND COMPANY

NEW YORK BOSTON LONDON

Copyright © 2014 by The Onion, Inc.

Little, Brown and Company
Hachette Book Group
1290 Avenue of the Americas, New York, NY 10104
littlebrown.com

First Edition: November 2014

Little, Brown and Company is a division of Hachette Book Group, Inc. The Little, Brown name and logo are trademarks of Hachette Book Group, Inc.

The publisher is not responsible for websites (or their content) that are not owned by the publisher.

The Hachette Speakers Bureau provides a wide range of authors for speaking events. To find out more, go to hachettespeakersbureau.com or call (866) 376-6591.

ISBN: 978-0-316-25645-2
Library of Congress Control Number: 2014940629
10 9 8 7 6 5 4 3 2 1

Q-KY

Printed in the United States of America

EDITOR
Cole Bolton

HEAD WRITER
Chad Nackers

MANAGING EDITOR
Ben Berkley

SENIOR EDITOR
Jason Roeder

FEATURES EDITOR
Jocelyn Richard

SENIOR WRITERS
Jermaine Affonso, Django Gold, Jen Spyra, Seena Vali

EDITORIAL COORDINATOR
Marnie Shure

SENIOR GRAPHICS EDITORS
Eric Ervine, Jimmy Hasse

GRAPHICS EDITOR
Heidi Unkefer

BOOK DESIGNER
Jenny Nellis

SPECIAL THANKS
Gene Albamonte, Adam Albright-Hanna, Alex Blechman, Joanna Borns, Jamie Brew, Aaron Burdette, Shira Rachel Danan, Mike DiCenzo, Scott Dikkers, Wes Drew, Mike Drucker, Tricia England, Steve Etheridge, Morgan Evans, Michael Faisca, Josh Freedman, Nick Gallo, Megan Ganz, Joe Garden, Mike Gillis, Ben Grasso, Dan Guterman, John Hallmann, Todd Hanson, John Harris, Tim Harrod, Brian Janosch, Anne Johnson, Chris Karwowski, Louisa Kellogg, Ellie Kemper, Gary Kercheck, Dan Klein, Matt Klinman, Peter Koechley, Carol Kolb, Dave Kornfeld, John Krewson, Jackie Lalley, Mike Loew, Kurt Luchs, Steve Macone, Eric March, Justin Maxwell, Dan McGraw, Johnny McNulty, David McQuary, Arthur Meyer, Lane Moore, Jill Morris, Sarah Naftalis, Andrei Nechita, Patrick O'Brien, Tara O'Brien, Agathe Panaretos, Jenny Paulo, Chris Pauls, Matt Phelan, Michael Pielocik, Zack Poitras, Joe Randazzo, Seth Reiss, Scott Rogowsky, Sarah Rosenshine, Jim Rowley, Maria Schneider, Michael Schwartz, Dave Sherman, Nick Stefanovich, Sigmund Stern, Jack Stuef, Colin Tierney, Will Tracy, Amos Vernon, Tracey Wigfield

FOREWORD

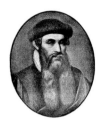

When I set out to revolutionize the printing process nearly six centuries ago, I held a grand vision of what my work might achieve. I foresaw a future in which my movable-type press served as the greatest boon to the spread of knowledge in the history of human civilization. Through mass reproduction technology, texts would spring off the metal plates and into the hands of millions of souls impoverished by ignorance. Tracts, broadsheets, and magnificent treatises would flow through the streets like life-giving water over a parched riverbed! Every home, no matter how humble or unclean, could possess a library stocked with the greatest works imaginable. Every child, no matter how dirt-caked and tubercular, could study the written word and be elevated to a higher station in life, perhaps even rising to attain employment in such desirable professions as executioner or ropemaker through mere book-learning alone! *Meine Güte*, the potential of my innovation was truly breathtaking indeed!

But, *ach*, it was not to be. In the years following my invention, I watched in stunned horror as my machine was utilized not to circulate literary works exemplifying truth and beauty, but to produce writings so unenlightened, so vile, so dribbling with diseased pus, that I quickly came to rue my ghastly role in disseminating literacy. You may know these stomach-turning abominations that my machine birthed: *Don Quixote, Common Sense, Candide, The Critique of Pure Reason*, the scrawlings of that cow-brained dunce William Shakespeare. What's more, my printing press also made possible wider contamination from such long-buried curses as Homer's *Iliad*, the *Histories* of Herodotus, and the Old Testament. The thought of it makes me retch even now! Had I foreseen what feculence was to burst forth from my beloved apparatus, I would have smashed it to bits right in my workshop!

Now, however, after 564 years of suffering and torment, the rotten blackness in my heart has been replaced with gaiety. With the publication of *The Onion Magazine: The Iconic Covers That Transformed an Undeserving World*, my invention has at long last revealed its full power! Within these magnificent pages—each one agleam with holy perfection as if handed down from the Heavens by our Maker Himself—fortunate readers will discover what I truly aspired to achieve with my printing press: full-color reproductions of *The Onion's* weekly magazine covers!

O, the glorious prose and imagery in this volume! One and all must behold this immaculate tome which finally brings redemption to the printed word after generation upon generation of excreta produced by Balzac, Longfellow, Dostoyevsky, Anne Frank, Merriam and Webster, and so many, many other contemptible filth-peddlers.

Granted, this is not the first time that *The Onion* has demonstrated the immense possibilities of published text. Indeed, since its inaugural issue in 1765, the periodical has gone to great lengths to counterbalance the harm wrought by atrocities such as *On the Origin of Species* and the Emancipation Proclamation. But through the production and global circulation of *The Onion Magazine: The Iconic Covers That Transformed an Undeserving World*—a faultless compendium whose merits I can say with absolute certainty will never be exceeded—my beloved printing press has both realized its true purpose and reached its august pinnacle.

So while this foreword serves as a humble introduction to the unfettered brilliance contained within these precious few pages, it is also an expression of my measureless gratitude to *The Onion* for what they have done for me. Each time I revel in the excellence contained herein, I am reminded—and relieved—to find that my work ultimately did far less harm than good on this earth. *Ich danke Ihnen.*

Johannes Gutenberg
October 2014

THE ONION MAGAZINE
THE ICONIC COVERS THAT TRANSFORMED AN UNDESERVING WORLD

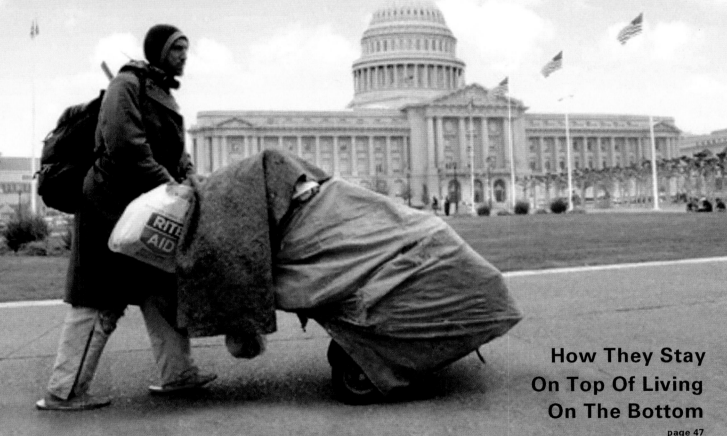

The Onion Magazine

AUGUST 15, 2005

America's Homeless
Still The Best In The World?

How They Stay
On Top Of Living
On The Bottom
page 47

The Ten Most Ingenious
Change-Acquisition
Operations In The Country

page 92

Food Scraps Or Pocket Change:
What To Give When You Just Want
To Feel Better About Yourself

page 153

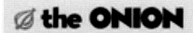

the ONION

AUGUST 22, 2005

WEEKENDER

FAILING
Is This *Your* Year?

SPECIAL
BACK TO SCHOOL
ISSUE

Dealing With Bullies At The Post-Graduate Level
Page 36

Internships: Pointless or Meaningless?
Page 18

Plus: The Inspirational And Surprisingly Erotic Story Of 84-Year-Old Bertha Puttnam's Return To College

2

ONION WEEKENDER

Plees Keep my legs safe for Me in Heaven

Please Jesiz, Don't let them try mee as a adult

Superstitious, Needy Children's
Letters to God

God, Will you kill Danny Roberts?

i think i should have been bornded a girl

INSIDE: Does God Understand Letters Not Written In English?

3

ONION WEEKENDER

⁓ THE ONION ⁓

A List Of Celebrities Written Down & Numbered

Page After Page Of Publicity Photos Accompanied By Vapid, Easy-To-Skim Captions
page 18

Are You An Internationally Famous Media Figure? Take Our Quiz And Find Out!
page 63

Plus: The Men Behind The Buzz: A Look At Entertainment News' Hottest Celebrity-List Makers

4

ONION WEEKENDER

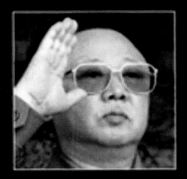

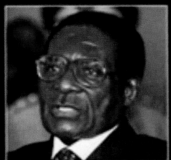
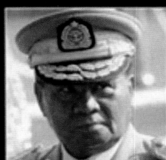
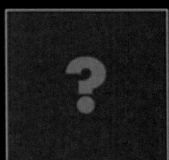

Who Is The World's Best Dictator?

By Alan Wiesinger

PLUS: At Home With That One Guy On That One Show

ONION WEEKENDER

People said she didn't have the determination, the drive, or the looks to succeed in one of the most difficult industries in America. They didn't know Jennifer Garner.

"My Perfect Teeth Will Carve A Mural Of Pain In Your Flesh"

page 38

INSIDE: Where Did We Come From? 14 Parents Awkwardly Explain PLUS: Minorities To Watch Out For

6

The Onion Magazine

DECEMBER 11, 2005

Foreigners
Do They Love Their Countries More Than Ours?

By Gerald Stent

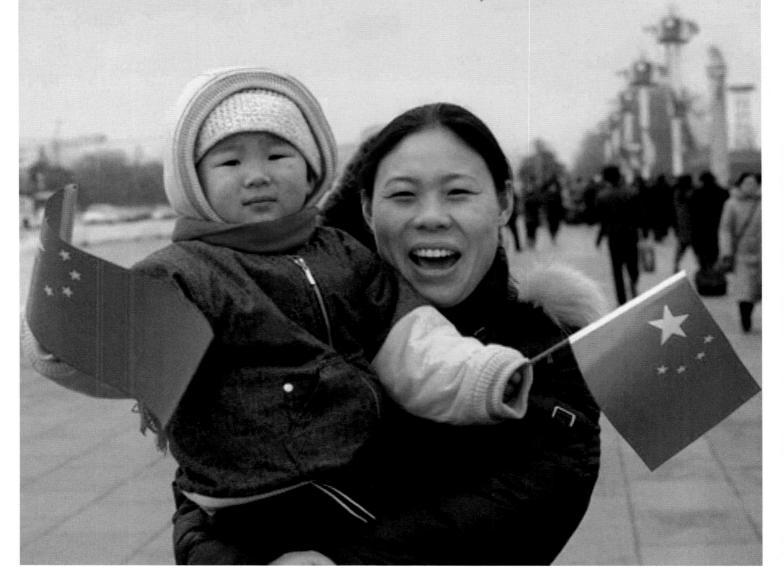

THE ONION WEEKENDER

"I Enjoy Wearing A Turtleneck"

Why Turtlenecks Are Back
And Why This Man Is
Crucial To Their Resurgence

An Interview
By Gerry Halliday

Inside: The Year In Schmaltzy Photos

The Onion Magazine

JANUARY 22, 2006

OUR FRAGILE ECOSYSTEM

Can It Continue To Turn A Profit?

By Eric Kostlinger

FEBRUARY 5, 2006

ONION WEEKENDER

The 100 WORST SENATORS

INSIDE: Mature, Committed Relationships And How To Avoid Them

10

The Onion Magazine

FEBRUARY 12, 2006

PSEUDOSCIENCE
Is It Catching Up To Real Science?

By Robin Ainsworth

FEBRUARY 26, 2006

ONION WEEKENDER

"Please Stop Casting Me"

A Plea From The Heart Of America's Leading Man

INSIDE Are Islamic Fundamentalists Too Easily Offended? Six Major Sects Take Our Humor Test

The Onion Magazine

MARCH 5, 2006

Books

What's All The Buzz About?

BY ANDREW ARTHUR

ONION WEEKENDER

46-year-old John McCain is a Baltimore-area plumber and father of two. He likes woodworking, reading history novels, and cooking. He is not the Arizona senator we believed we had profiled inside this magazine.

"I Think You May Be Looking For The Other John McCain"

Page 25

INSIDE Which Suicide Method Is Best For You

14

The Onion Magazine

MARCH 26, 2006

The Hidden Buddhist Threat In Our Midst

A Special Report By Eric Scopelli

The Onion Magazine

APRIL 2, 2006

PHOTO ISSUE

America's Worthless Old Sheds

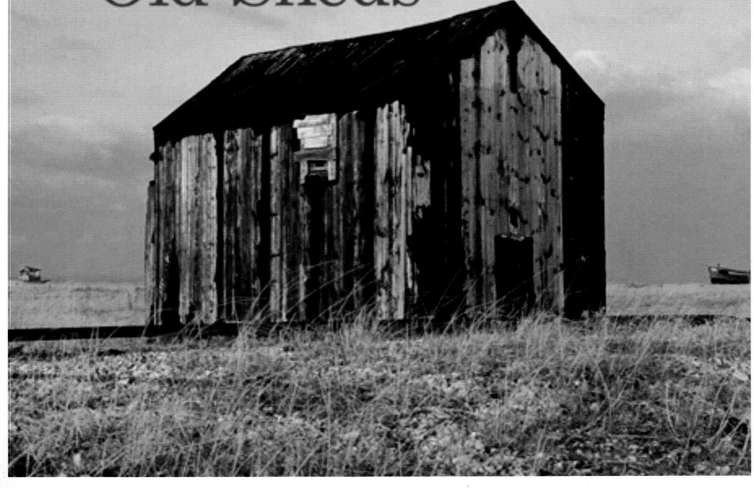

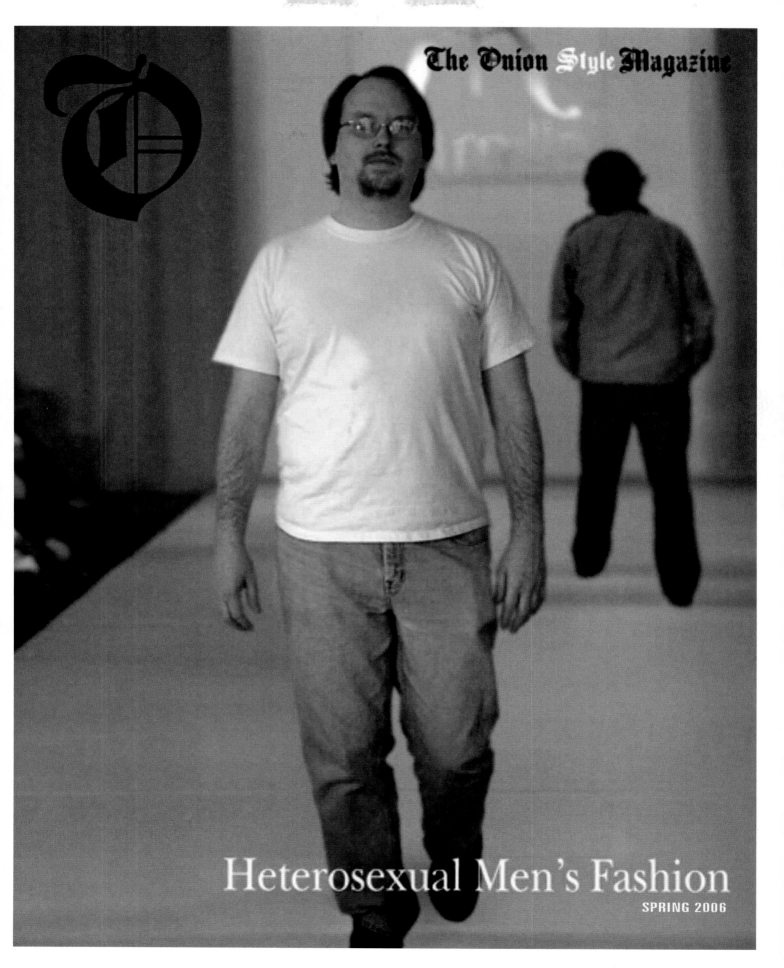

Heterosexual Men's Fashion

SPRING 2006

ONION WEEKENDER

He battled drugs, depression, and demons, but now he's back on top and ready to re-conquer Hollywood.

"Crack Nearly Killed Me"

Bill Nye speaks, page 23

INSIDE Constant Rage: Could People Fucking Up All The Time Be To Blame?

18

ONION WEEKENDER

Outlive Your Kids

An exciting report shows how new health trends are bringing the unthinkable within reach.

Page 37

Inside How *You* Can Pay More For Gas

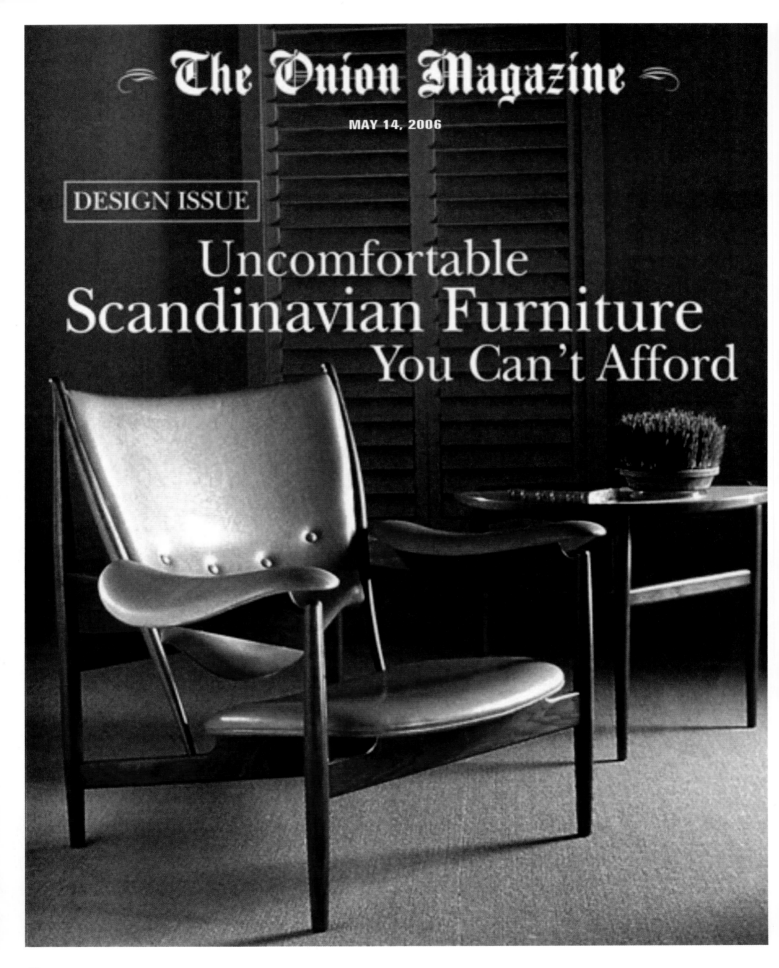

The Onion Magazine

MAY 14, 2006

DESIGN ISSUE

Uncomfortable Scandinavian Furniture
You Can't Afford

The Onion Magazine

MAY 28, 2006

Is It Time To Forget About Afghanistan?

By Gerald Stent

ONION WEEKENDER

SPECIAL REPORT

Using The Internet To Radically Misdiagnose Your Children

Page 27

Inside Tony Danza: "It's Hard To Be A Talk-Show Host, But Not That Hard"

The Onion Magazine

JUNE 25, 2006

COULD YOUR CHILDREN SUDDENLY DROP DEAD FOR NO REASON?

The Onion Magazine

JULY 2, 2006

Child Labor's Hidden Adorable Side

By Gerald Stent

The Onion Magazine

JULY 23, 2006

WILL MAN EVER PUT NUKES ON THE MOON?

BY WADE McKANNIS

ONION WEEKENDER

Top Vacation Spots For People Like You

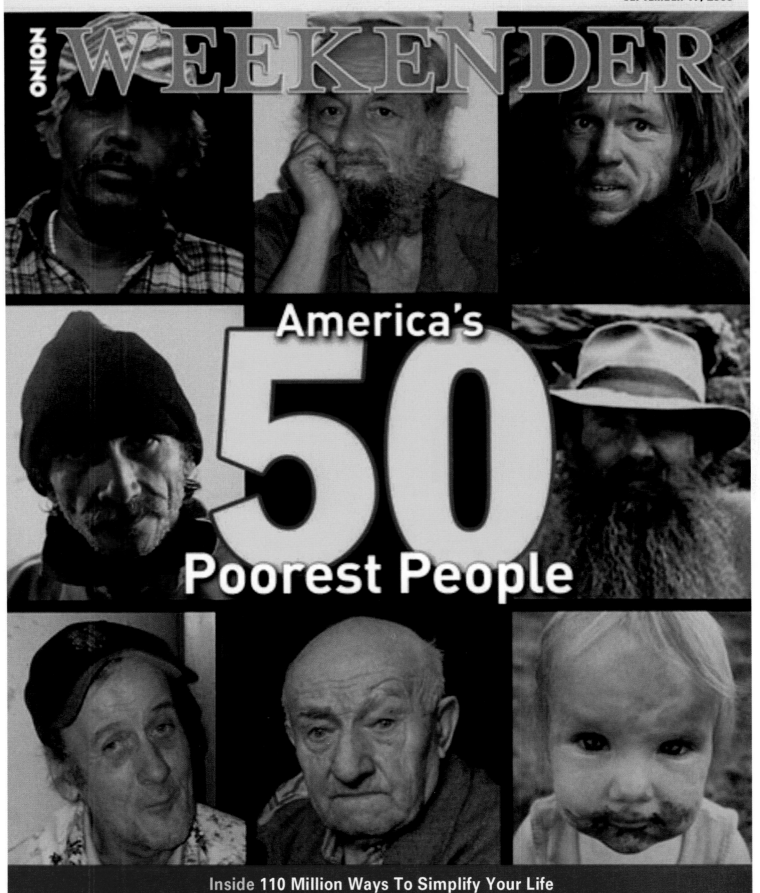

ONION WEEKENDER

America's 50 Poorest People

Inside **110 Million Ways To Simplify Your Life**

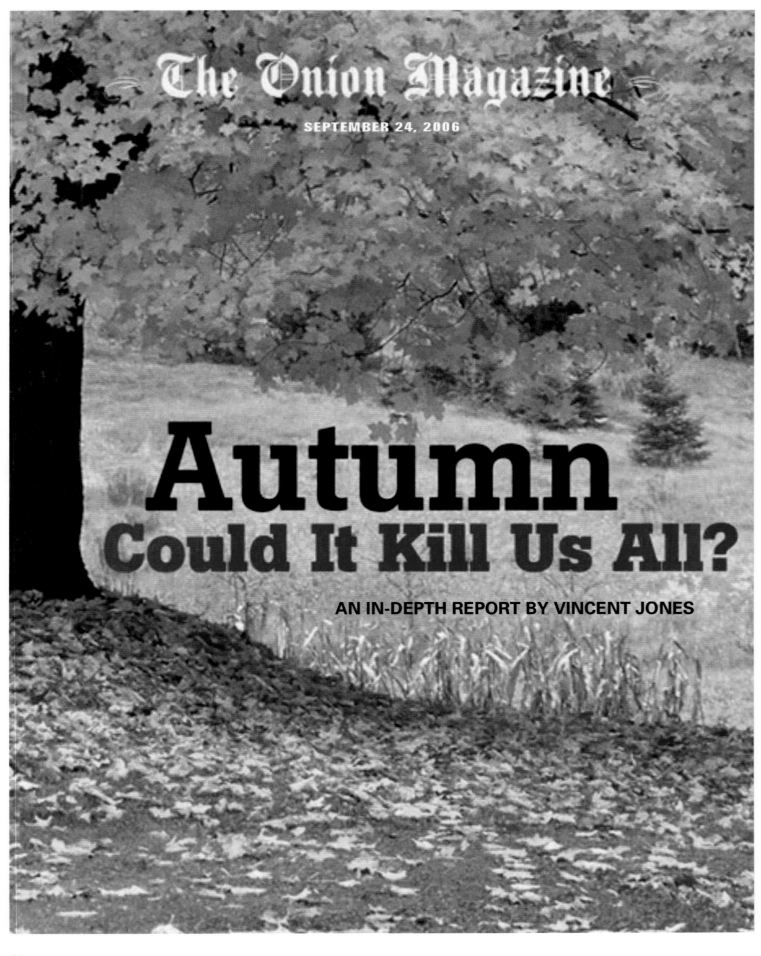

The Onion Magazine

SEPTEMBER 24, 2006

Autumn
Could It Kill Us All?

AN IN-DEPTH REPORT BY VINCENT JONES

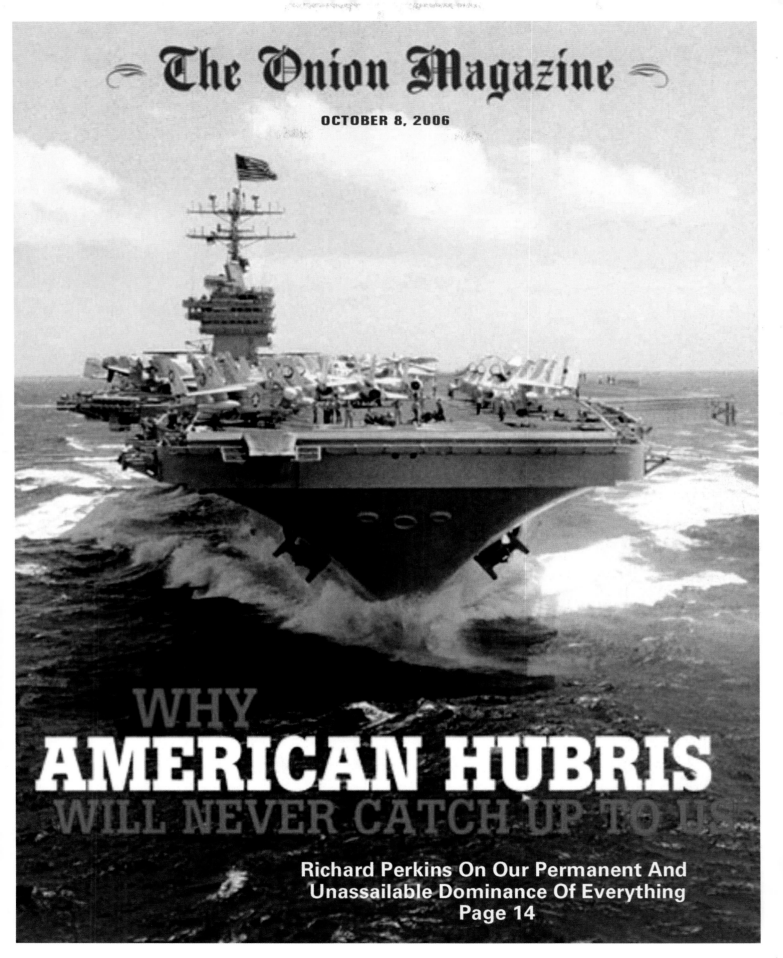

The Onion Magazine

OCTOBER 8, 2006

WHY
AMERICAN HUBRIS
WILL NEVER CATCH UP TO US

**Richard Perkins On Our Permanent And Unassailable Dominance Of Everything
Page 14**

ONION WEEKENDER

Pretty Balloons!

Page 27

Inside: **Inside The Oldest Woman In America**

30

The Onion Magazine

OCTOBER 22, 2006

THE LINEN CLOSET
AMERICA'S NEW VIETNAM

BY SUSAN PORTKIN

The Onion Magazine

OCTOBER 29, 2006

Does Barack Obama Have What It Takes To Become The Lowest-Paid President In American History?

By Catherine Sorren

ONION WEEKENDER

Consummate networker and part-time receptionist Bill Walsh talks about his most remarkable connection yet:

"My Cousin Totally Works With Kate Hudson's Brother"

Page 27

Inside What Does Your 18-Wheeler Say About You?

ONION WEEKENDER

The Iranian president speaks:

"I Just Learned What The Holocaust Was, And Boy Do I Feel Silly"

By Mahmoud Ahmadinejad

Inside **Using Your Children To Pay Rent**

ONION WEEKENDER

"I Went From Being Attacked By Mountain Lions To Being Eaten By Mountain Lions To Being Digested And Excreted By Mountain Lions"

One Arizona Woman's Amazing Journey Page 22

Inside 10 Great Sleeping-In Ideas Plus We Preview The 2007 Doritos

ONION WEEKENDER

20 TERRORISTS UNDER 20

A Look At The Dynamic Youths Most Determined To Make A Difference In Your Community

Inside **Can The Super-Rich Save Christmas?**

ONION

WEEKENDER

WARNING!

THIS IS YOUR LAST ISSUE!

AVOID MISSING AN ISSUE AND RE-SUBSCRIBE NOW!

Inside Marriage: Are Your Gay Kids At Risk?

ONION WEEKENDER

Why It's Cool To Suck At Math

Page 22

Inside **How Solar Power Will Kill Us All**

38

The Onion Magazine

JANUARY 28, 2007

IS THE AMERICAN MEDIA RUNNING OUT OF FLUFF PIECES?

A SPECIAL REPORT BY TONY CORRELL

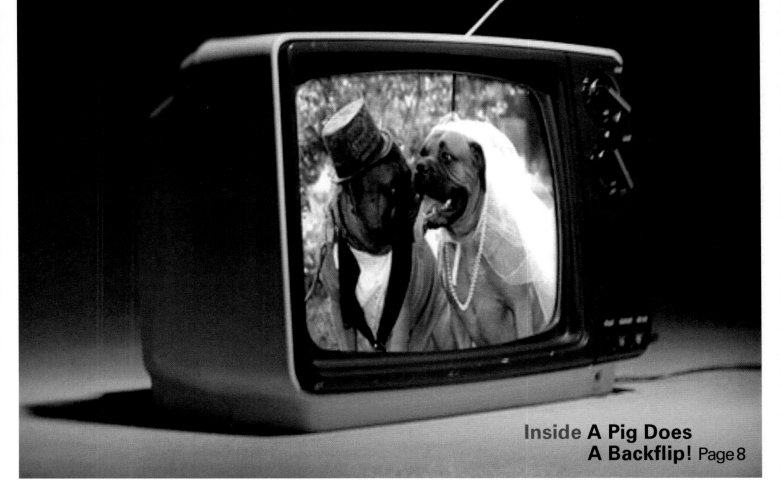

Inside **A Pig Does A Backflip!** Page 8

ONION WEEKENDER

This is a handmade clay tile artist Niki Glen made

Pike County citizens scramble in the Collector's week as the personal property tax deadline appro

Sparks is through the ound of auditions.

Dr. Gary M. Goldbaum starts Feb director.

Robert Miles is the man behind the Martin Luther King Jr. Roundball Classic.

George Montoya proudly displays his first catch of the day.

crowd with tradition

Rabbit judge Susan Origer, of Brainerd, Minn., measu ears of an English lop during a rabbit show at the Bob Ruud Community Center Saturday.

The *Onion Weekender's* Annual
Photo-Caption Issue

A credit card can double as an ice scraper.

Nice view of the snow freezing after it had melted and slid off the roof....

Horacio Pena packs pieces of flan

Sophi-Flan owner Horacio Pena packs pieces of flan.

On Thursday, Dec. 28 Pam Calvin (left) of Frankford and Dottie Gott (right) of Louisiana they were done under the wire

Abigail Monroe, 8, thinks about the word she has to spe at the El Dorado spelling bee on Friday morning.

Power lines are seen near of Grady, N.M., on Monday, Jan. 15, 2007.

Everclear will perform a free concert.

Pike County citizens scramble in the Collector's office las week as the personal property tax deadline approached.

A credit card can do as an ice s

A customer ente

ONION WEEKENDER

"I Was Suicidal And... Hey, Where Are You Going?"

We Lose Interest In Our Interview With Amanda Peet. Page 12

Inside If You Fold The Pages Right, You Can Make A Fan

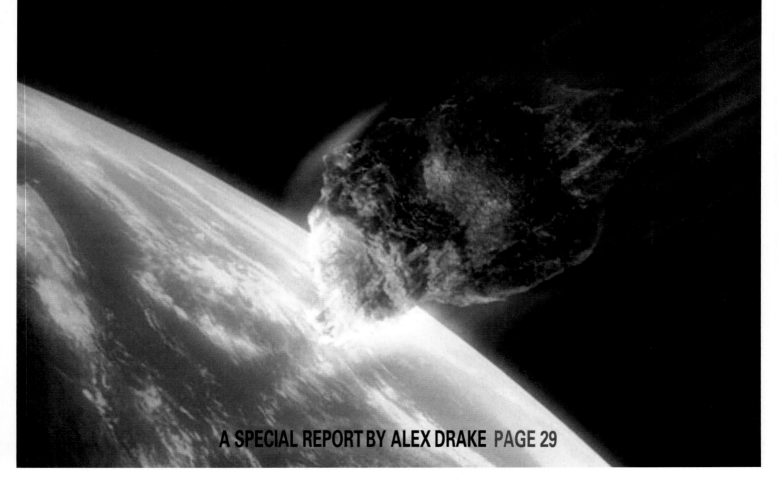

The Onion Magazine

MARCH 11, 2007

COULD THIS ASTEROID SOLVE GLOBAL WARMING, IRAQ, AND POVERTY?

A SPECIAL REPORT BY ALEX DRAKE PAGE 29

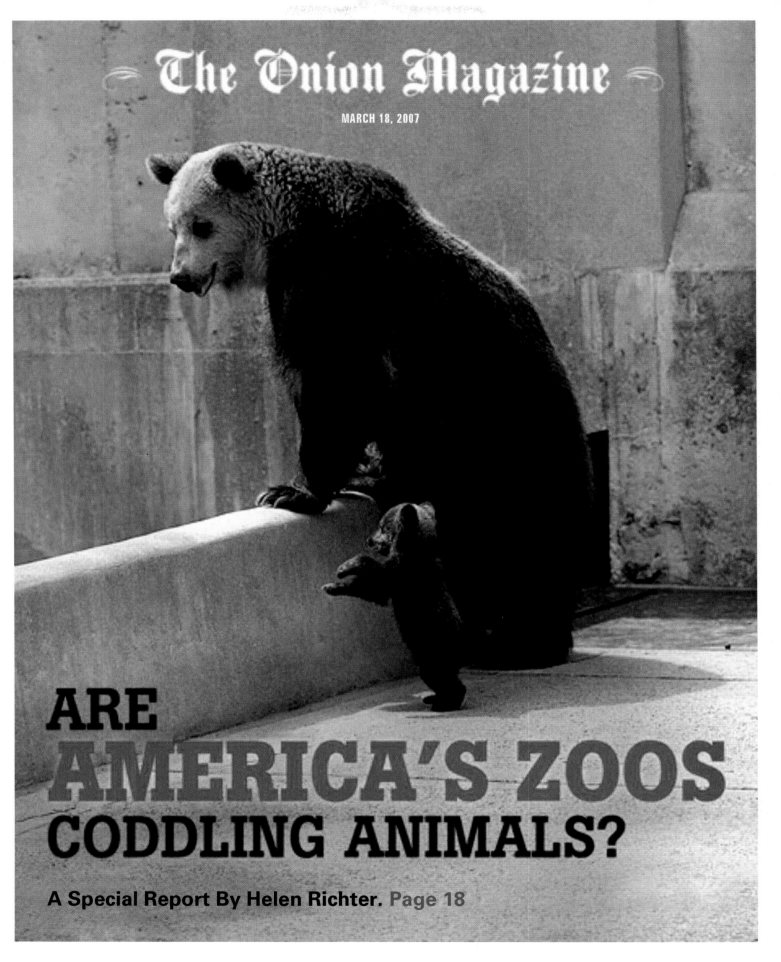

The Onion Magazine

MARCH 18, 2007

ARE AMERICA'S ZOOS CODDLING ANIMALS?

A Special Report By Helen Richter. Page 18

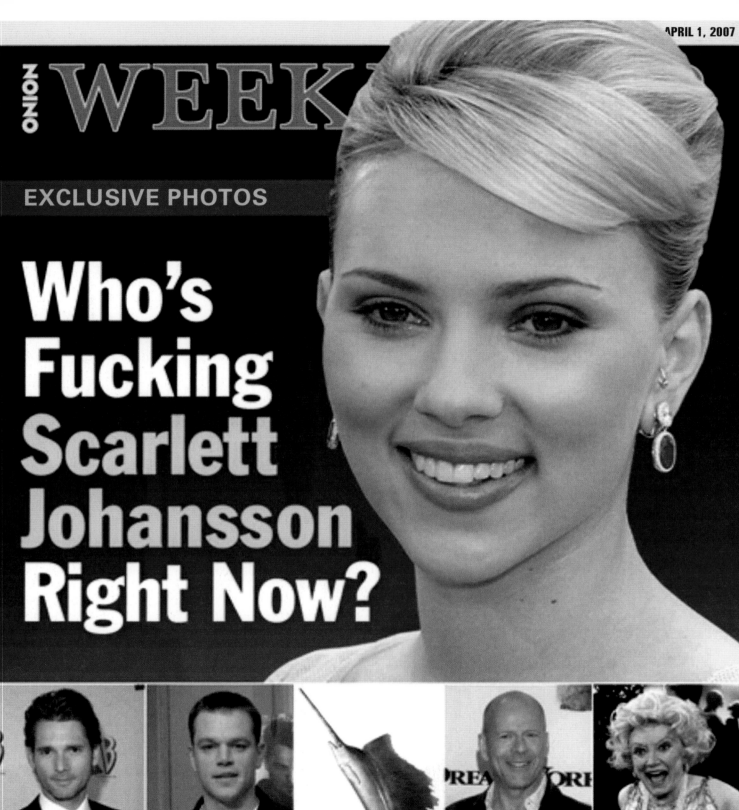

ONION WEEKLY

EXCLUSIVE PHOTOS

Who's Fucking Scarlett Johansson Right Now?

| ERIC BANA | MATT DAMON | A SWORDFISH | BRUCE WILLIS | PHYLLIS DILLER |

Inside How To Protect Yourself From The 2008 Elections

44

ONION WEEKENDER

Turning Your
SPARE
TIME
Into
WORK
TIME

Six Tips From The Pros
Page 26

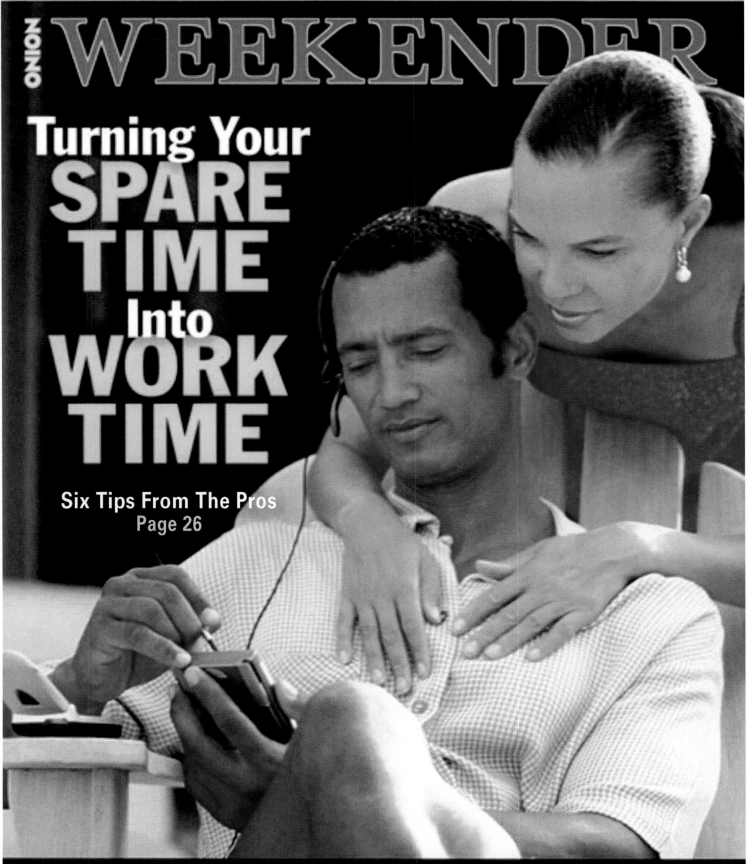

Inside Is It Right To Pit Your Children Against One Another?

45

The Onion Magazine

APRIL 15, 2007

FINDING A RELIGION
THAT DOESN'T DISRUPT YOUR CURRENT LIFESTYLE

BY SIMON WARREN PAGE 17

46

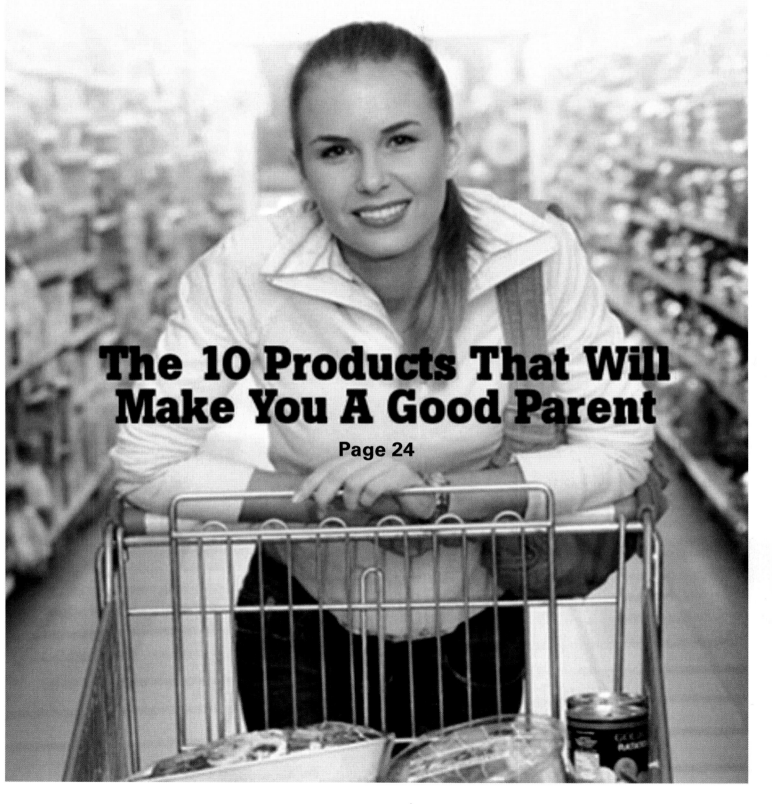

The Onion Magazine

APRIL 29, 2007

The 10 Products That Will Make You A Good Parent

Page 24

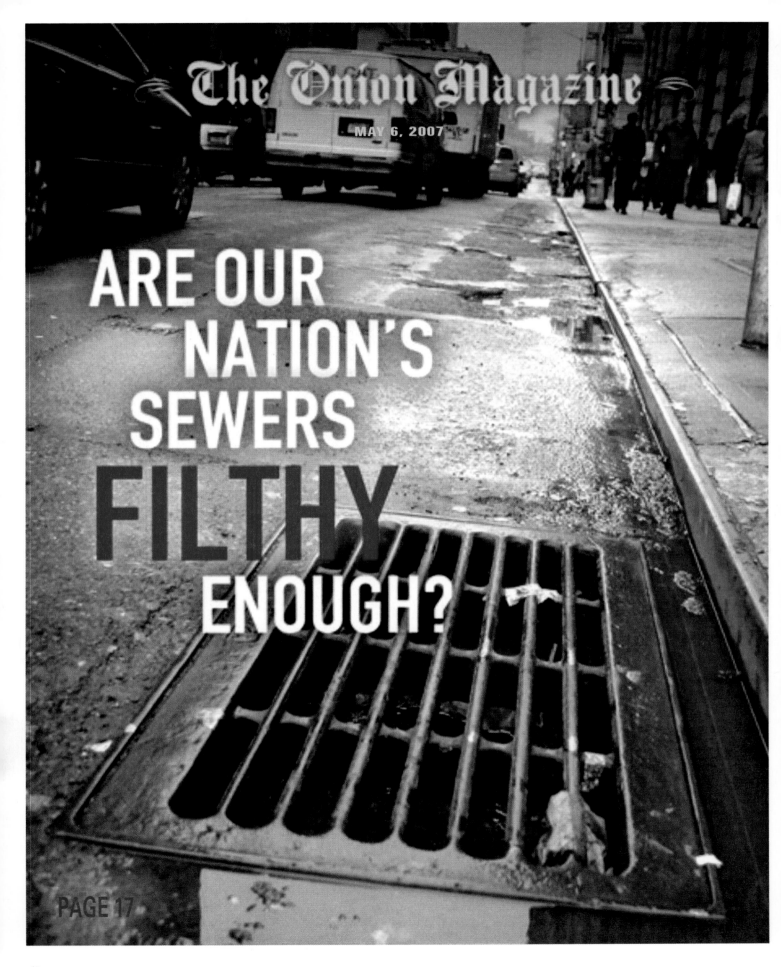

ONION WEEKENDER

Coping With Shit

Expert Advice For Emotional Weaklings Like You PAGE 17

Inside Could Your Marriage Be An Elaborate Stealth Marketing Scheme?

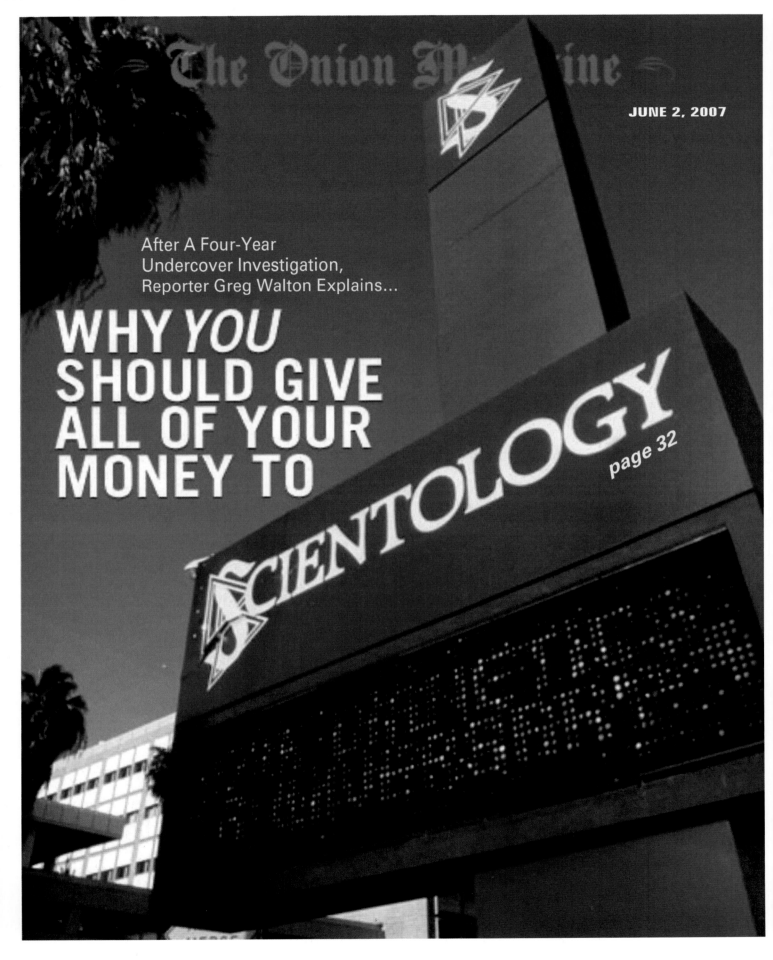

The Onion Magazine

JUNE 10, 2007

Leading
Republican
Candidate
And Mormon

MITT ROMNEY

Does He Wear That Weird Underwear?

PAGE 18

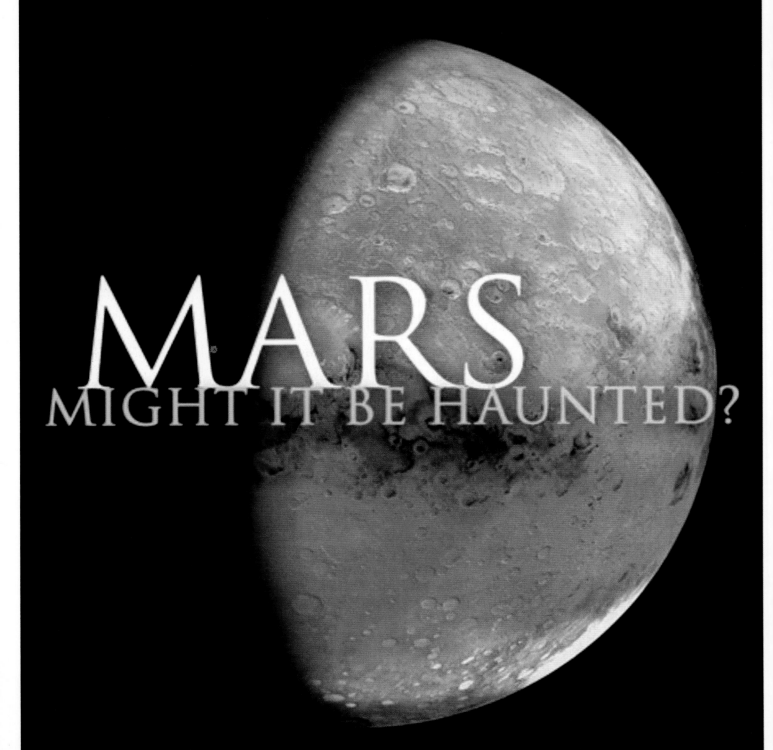

The Onion Magazine

JULY 22, 2007

MARS
MIGHT IT BE HAUNTED?

NASA'S NEW OBSESSION WITH THE AGE-OLD THEORY
ALICE LIVINGSTON

The Onion Magazine

JULY 29, 2007

SIDES

ARE YOU ON THE RIGHT ONE?

BY STEVEN PITHER

ONION WEEKENDER

Could Somebody Be Right Behind You?

Page 21

Inside Are The Young, Fit, And Attractive Having Too Much Sex?

54

ONION WEEKENDER

Is Your Babysitter On Your Drugs?

Page 16

INSIDE What Your Clothing Says About The Size Of Your Body

ONION WEEKENDER

*Facebook's
Mark Zuckerberg*

PAGE 21

WE SIT DOWN WITH
The Smug Little Shit Behind The Latest Internet Phenomenon

INSIDE **An In-Depth Look Into The Monotonous And Repetitive World Of Reggaeton**

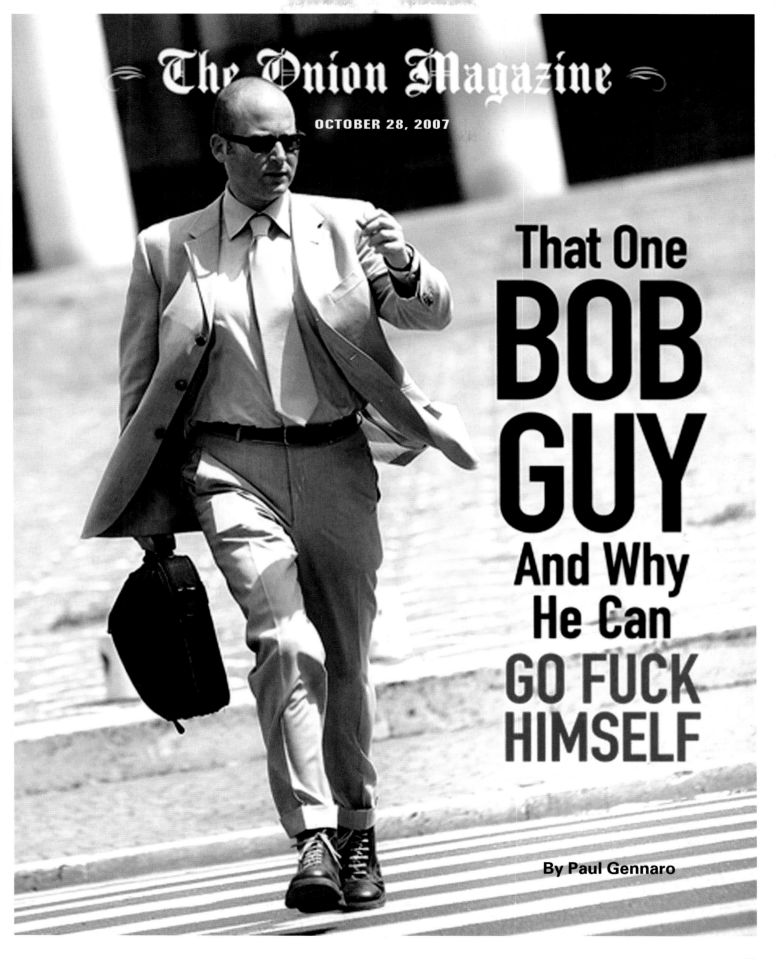

The Onion Magazine

OCTOBER 28, 2007

That One
BOB
GUY
And Why
He Can
GO FUCK
HIMSELF

By Paul Gennaro

The Onion Magazine

NOVEMBER 4, 2007

'Oh What A Shame'

And Other Phrases To Help You Get Through The Crisis In Burma

By Thomas Merfeld

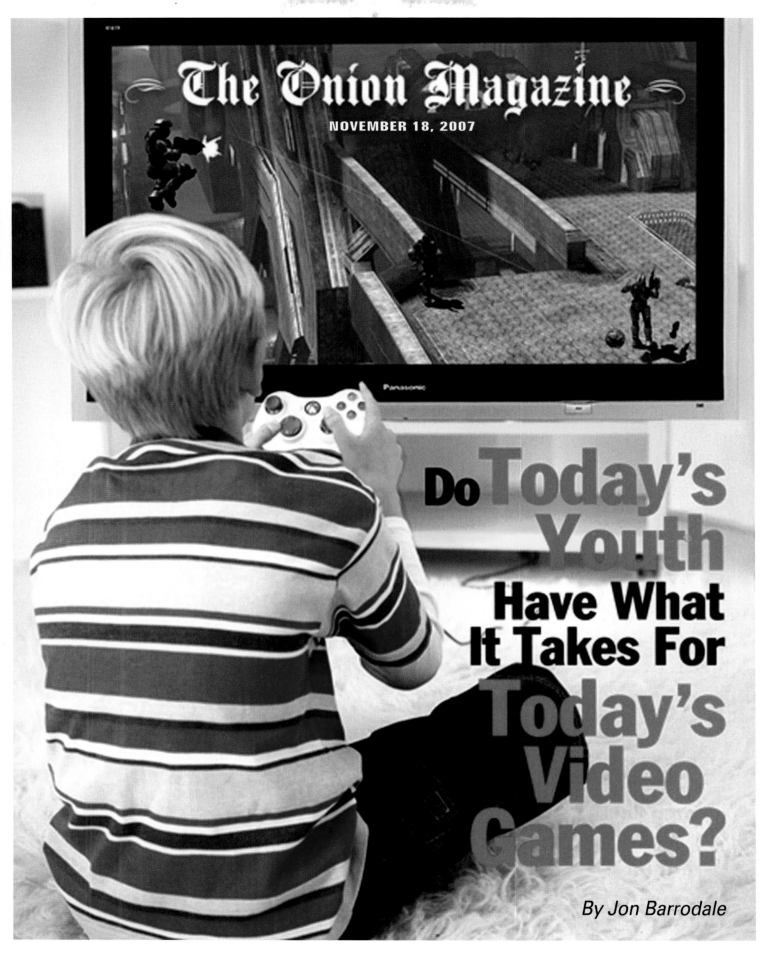

The Onion Magazine

NOVEMBER 18, 2007

Do Today's Youth Have What It Takes For Today's Video Games?

By Jon Barrodale

The Onion Magazine

NOVEMBER 25, 2007

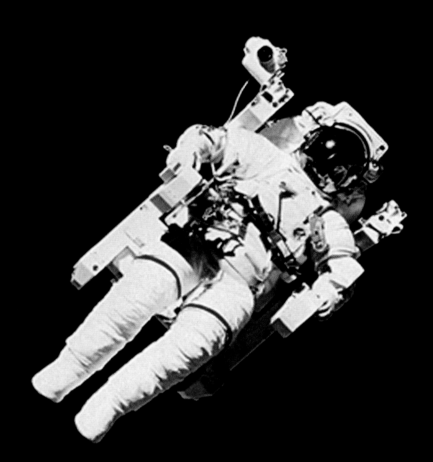

OUR ASTRONAUTS

SHOULD WE BRING THEM BACK FROM SPACE?

By Robert E. Reiken

ONION WEEKENDER

Ways To Get The OPPOSITE SEX'S ATTENTION Without Juggling

PAGE 18

INSIDE 198,432 Books You Won't Read Before You Die

61

ONION WEEKENDER

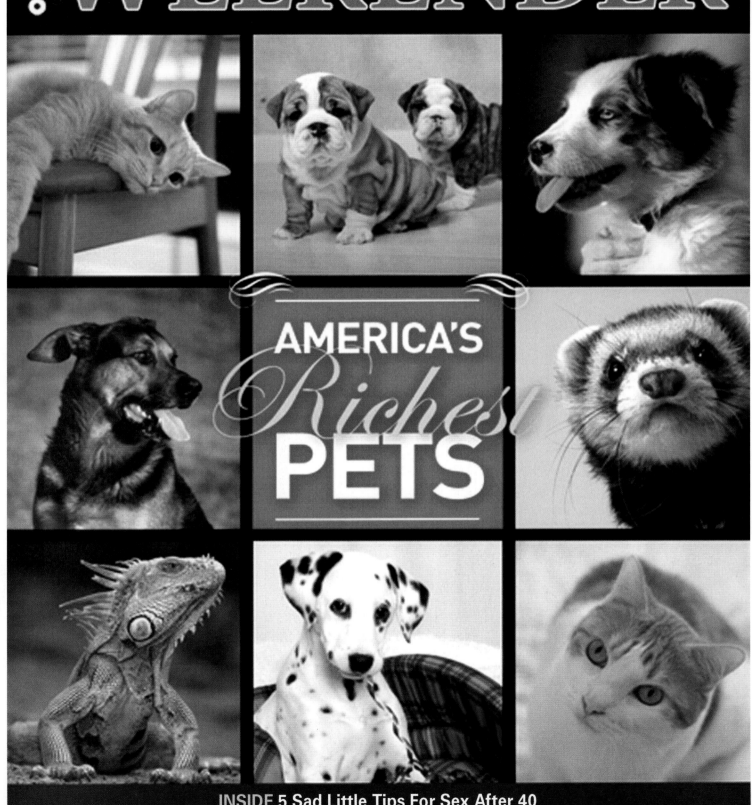

AMERICA'S *Richest* PETS

INSIDE 5 Sad Little Tips For Sex After 40

The Onion Magazine

DECEMBER 16, 2007

THE FUTURE OF
TIME TRAVEL
Is It Also Its Past?

By Robert Trebor

ONION WEEKENDER

"I Almost Died"

One Mother's Unbelievably Long And Tedious Story

Page 28

INSIDE 30 Young People Who Have Given Up Before The Age Of 30

64

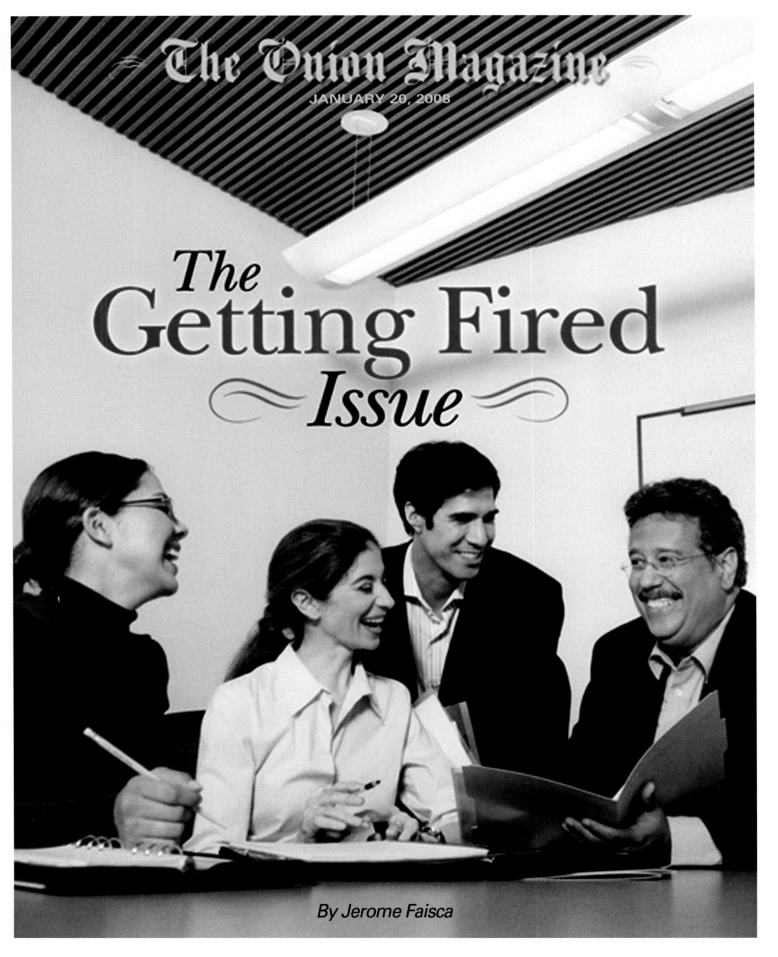

The Onion Magazine

JANUARY 20, 2008

The Getting Fired Issue

By Jerome Faisca

The Onion Magazine

JANUARY 27, 2008

Are Our CHILDREN'S Masturbation Fantasies Getting TOO SEXY?

BY MICHELLE LEE

FEBRUARY 3, 2008

ONION WEEKENDER

PAGE 16

ONE MAN'S BRAVE BATTLE
Against Stuffing His Fat Face With Fruit Pies

INSIDE The Best-Sellers That Will Be Turned Into The 2010 Fall Movie Season

ONION WEEKENDER

OUR NATION'S HEROES

Are Any Of Them Single?

PAGE 29

INSIDE Local Warming: Could Very-Specific Climate Change Heat Our Burritos?

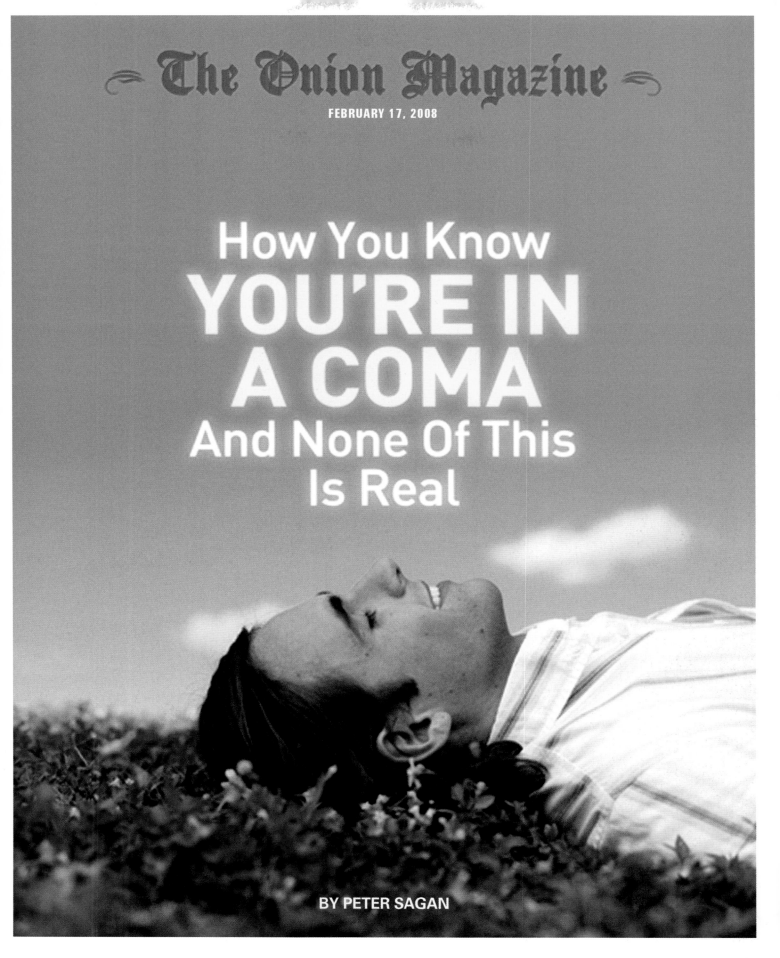

The Onion Magazine

FEBRUARY 17, 2008

How You Know YOU'RE IN A COMA And None Of This Is Real

BY PETER SAGAN

The Onion Magazine

FEBRUARY 24, 2008

Can Angels *Help You* Win The Lottery?

By Claire Whitman

The Onion Magazine

MARCH 2, 2008

Could Leaning With Your Head Against A Wall Cause DEPRESSION?

By Henry Bander

ONION WEEKENDER

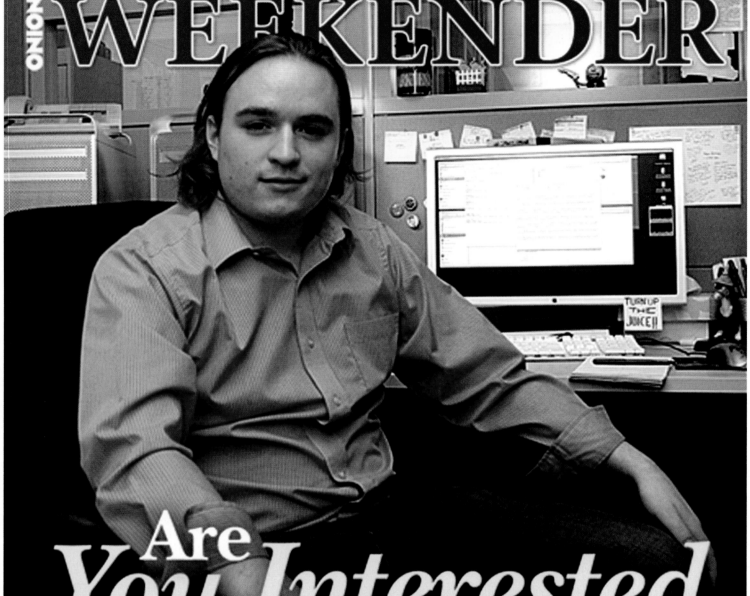

Are *You Interested* In Dating A Guy Who *Works At A Magazine?*

Page 25

INSIDE How Fucking Weird Are Salamanders?

The Onion Magazine

MARCH 30, 2008

TOP 10 PRODUCTS TO BATTLE CONSUMERISM

By Christoph Vorhang

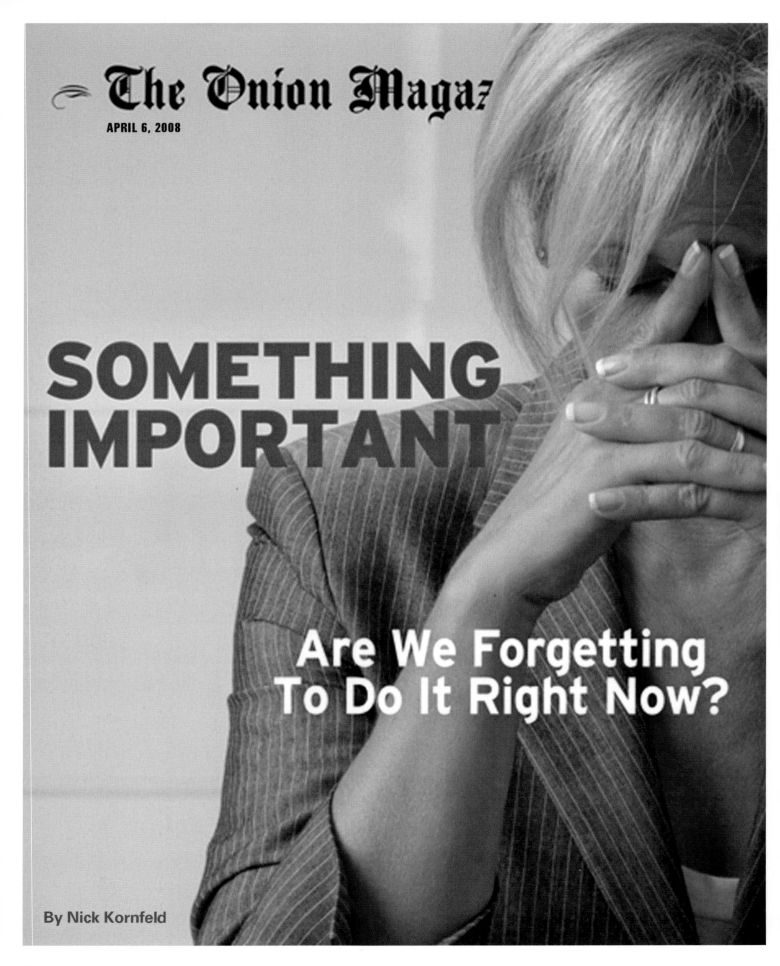

The Onion Magaz

APRIL 6, 2008

SOMETHING IMPORTANT

Are We Forgetting To Do It Right Now?

By Nick Kornfeld

ONION WEEKENDER

Meet The Polish *Selena*

Page 31

INSIDE The Health Benefits Of Eating Pistachios Until You Feel Sick

The Onion Magazine

APRIL 27, 2008

A Statement Followed By A Question Separated By A Colon:

An Effective Journalistic Technique?

By Dave Gallo

ONION WEEKENDER

Somersaulting Into
ONCOMING TRAFFIC

The Silent KILLER

Page 19

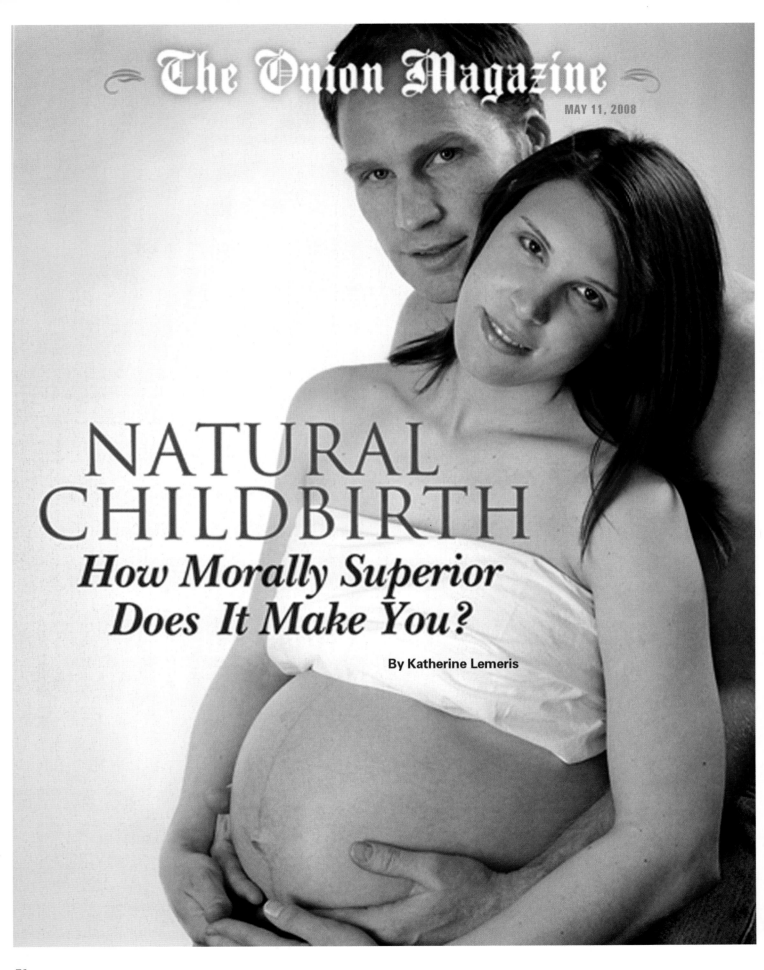

The Onion Magazine

MAY 11, 2008

NATURAL CHILDBIRTH
How Morally Superior Does It Make You?

By Katherine Lemeris

The Onion Magazine

MAY 25, 2008

Our Glossiest
Issue Yet

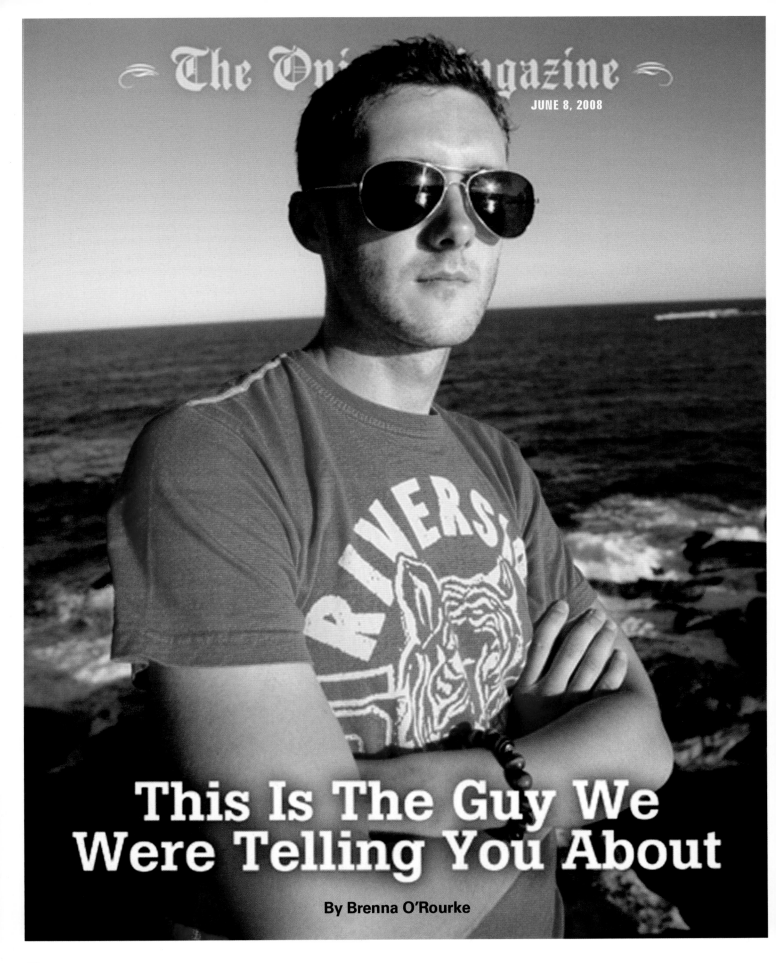

JUNE 8, 2008

This Is The Guy We Were Telling You About

By Brenna O'Rourke

ONION

WEEKENDER

JUNE 15, 2008

HOT TUBBIN'

WITH PROFESSIONAL HOT TUBBER ROB RYAN

PAGE 22

INSIDE **Temper Tantrums And How They Can Save You Money**

81

ONION WEEKENDER

50 MOST ATTAINABLE WOMEN

Inside Choosing A Paint Color That's Just Slightly Wrong For You

ONION WEEKENDER

AMERICA'S ASTRONAUTS

Who Will Be The Next To Die?

Page 21

Inside Eating Popcorn To Stay Healthy And Other Lies You Can Tell Yourselves

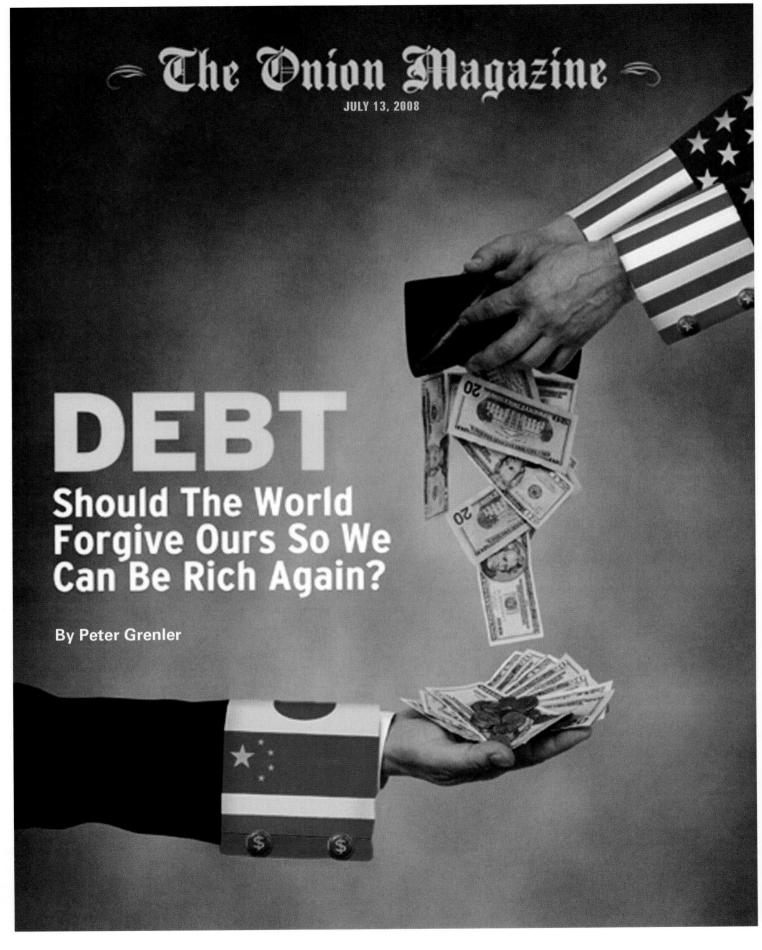

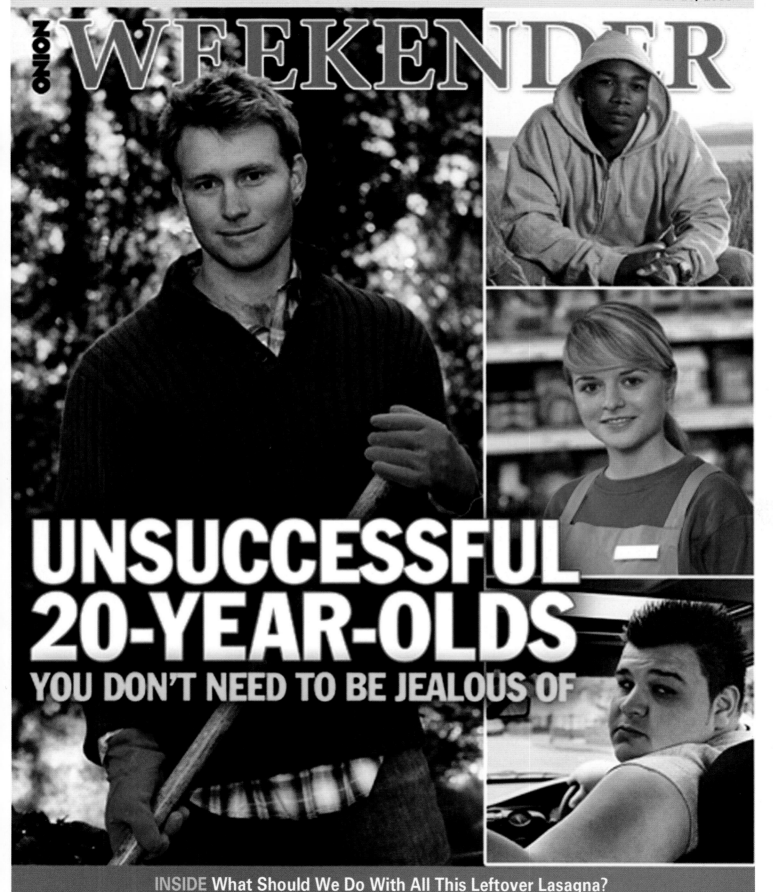

ONION WEEKENDER

UNSUCCESSFUL 20-YEAR-OLDS
YOU DON'T NEED TO BE JEALOUS OF

INSIDE What Should We Do With All This Leftover Lasagna?

ONION WEEKENDER

AUGUST 3, 2008

SPECIAL DELIVERY!

We Lose The Bidding War For Photos Of

BRANGELINA'S NEW TWINS

INSIDE **America's Favorite Noises**

The Onion Magazine

IS John McCain

SECRETLY RAISING HIS ARMS ABOVE HIS HEAD WHILE NOBODY'S LOOKING?

By Mark Frenkel

The Onion Magazine

AUGUST 17, 2008

We Overcome Our
Fears And Publish
This Photo Of A

SCARY SPIDER

By David Dubois

WEEKENDER

AUGUST 24, 2008

THE JONAS BROTHERS

We Find Out How Long They Can Last Without Oxygen

Page 28

89

The Onion Magazine

AUGUST 31, 2008

OUR ANNUAL
Worst Issue Of The Year
ISSUE

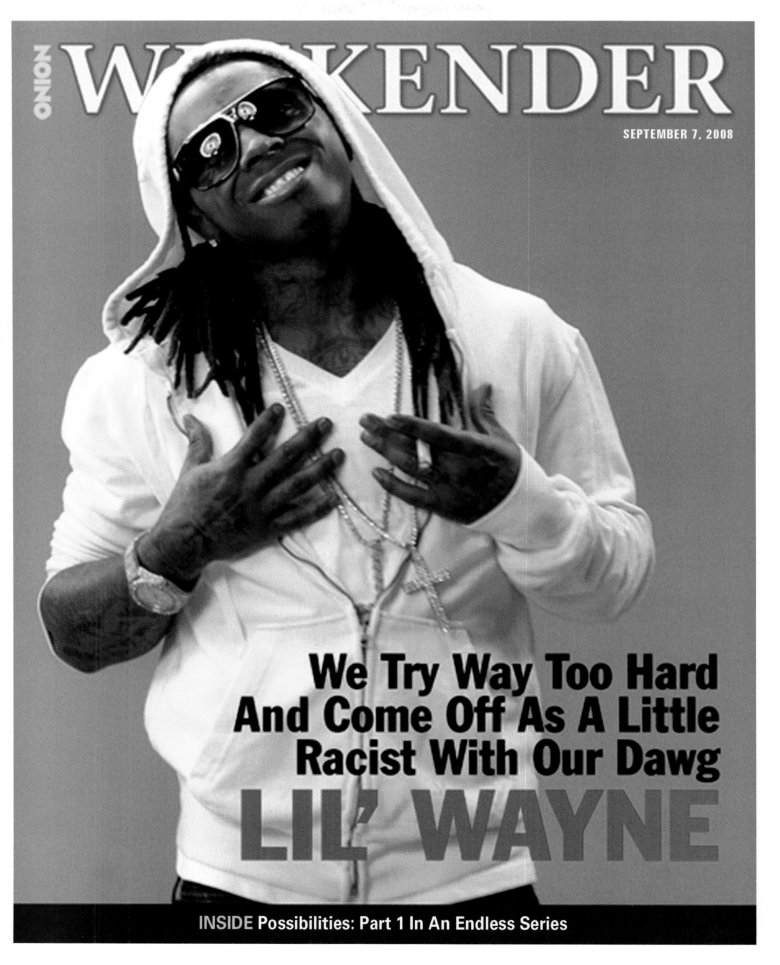

ONION

WEEKENDER

SEPTEMBER 7, 2008

We Try Way Too Hard And Come Off As A Little Racist With Our Dawg

LIL' WAYNE

INSIDE Possibilities: Part 1 In An Endless Series

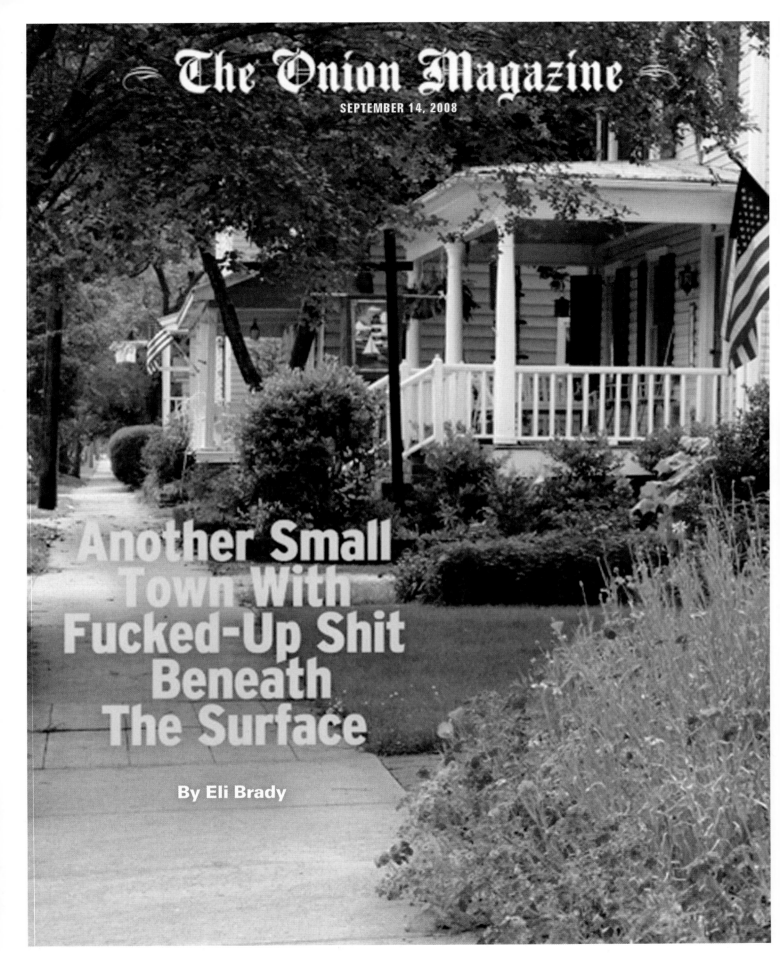

The Onion Magazine

SEPTEMBER 14, 2008

Another Small Town With Fucked-Up Shit Beneath The Surface

By Eli Brady

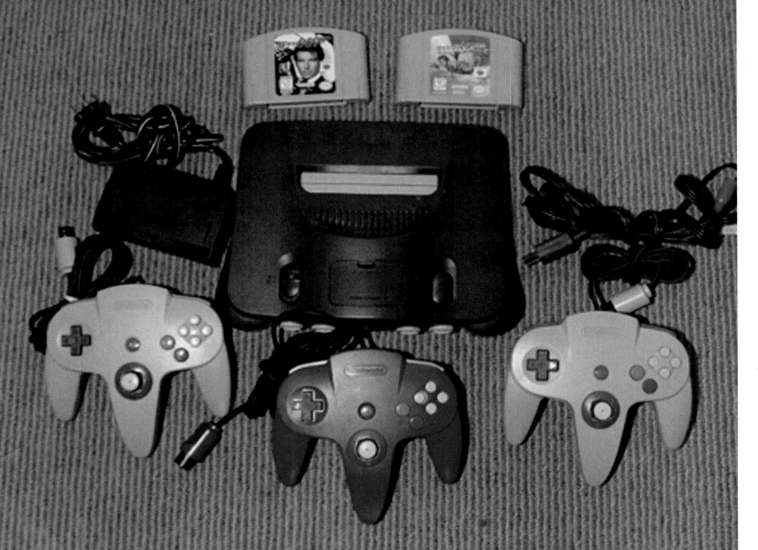

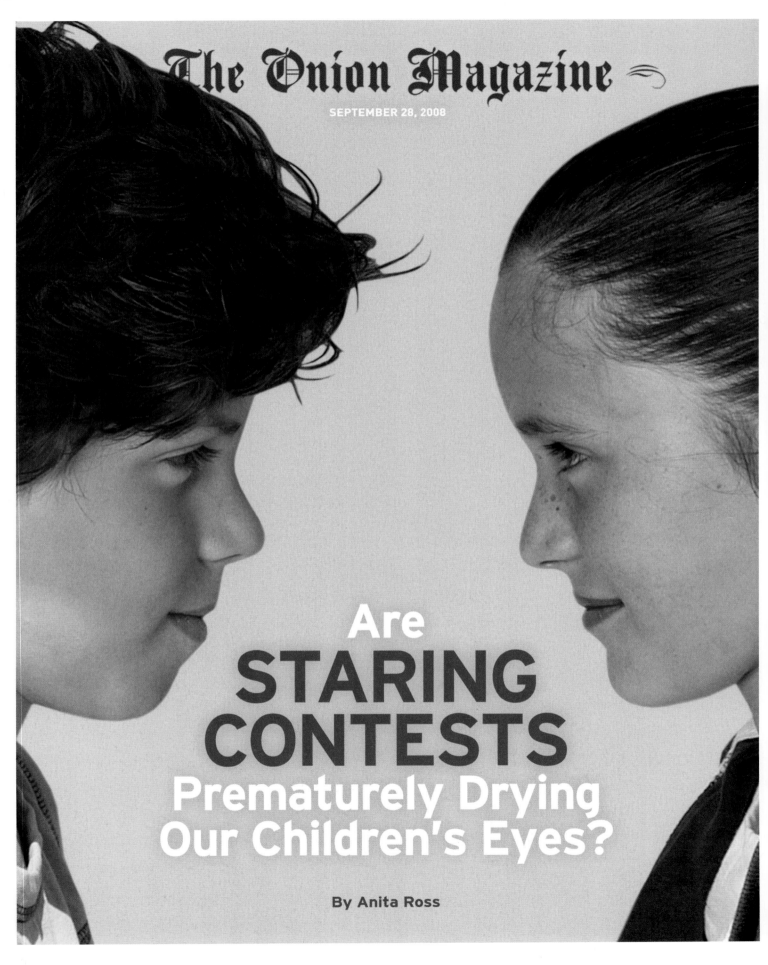

The Onion Magazine

SEPTEMBER 28, 2008

Are
STARING
CONTESTS
Prematurely Drying
Our Children's Eyes?

By Anita Ross

ONION WEEKENDER

OCTOBER 12, 2008

EXCLUSIVE

First-Ever Unretouched Photos Of The Weird Birthmark On **BARACK OBAMA'S FACE**

INSIDE Performing Thoracic Surgery With Common Household Items

The Onion Magazine

OCTOBER 19, 2008

How Will History Remember

Pol Pot?

By George Bristol

ONION WEEKENDER

NOVEMBER 2, 2008

10 TIPS FOR BEAUTIFUL HAIR

THE GOVERNMENT DOESN'T WANT YOU TO KNOW

INSIDE Your Bathroom Rug – Is It Always Damp?

97

The Onion Magazine

NOVEMBER 16, 2008

Are Tissue Box Designs Too OSTENTATIOUS For America's Bedside Tables?

By Penelope Grace

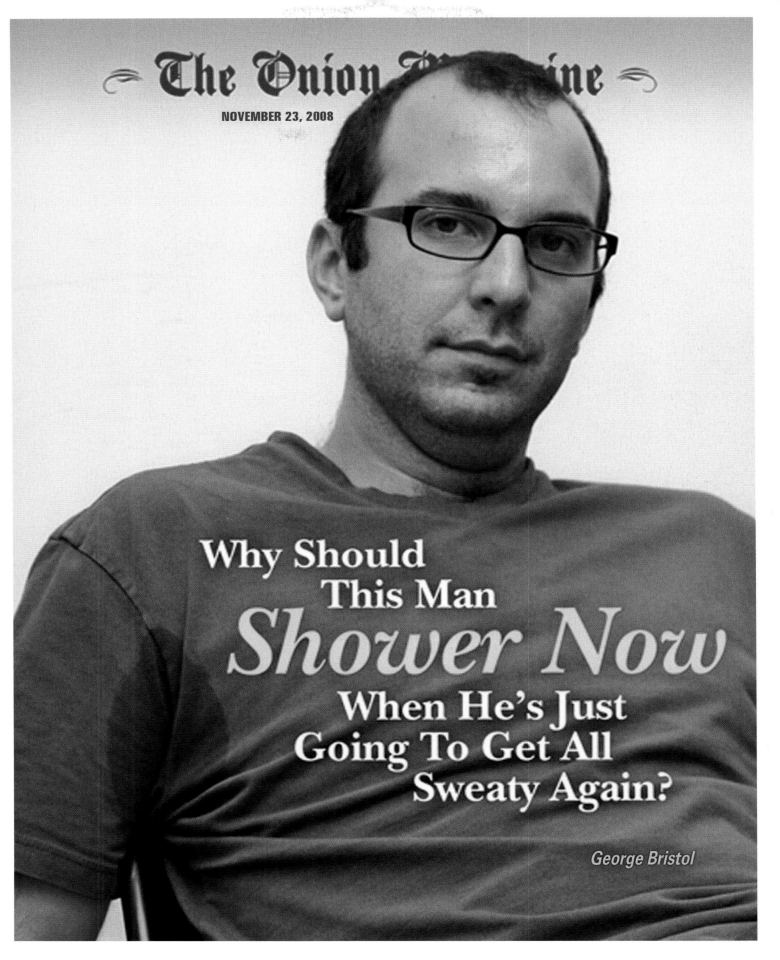

99

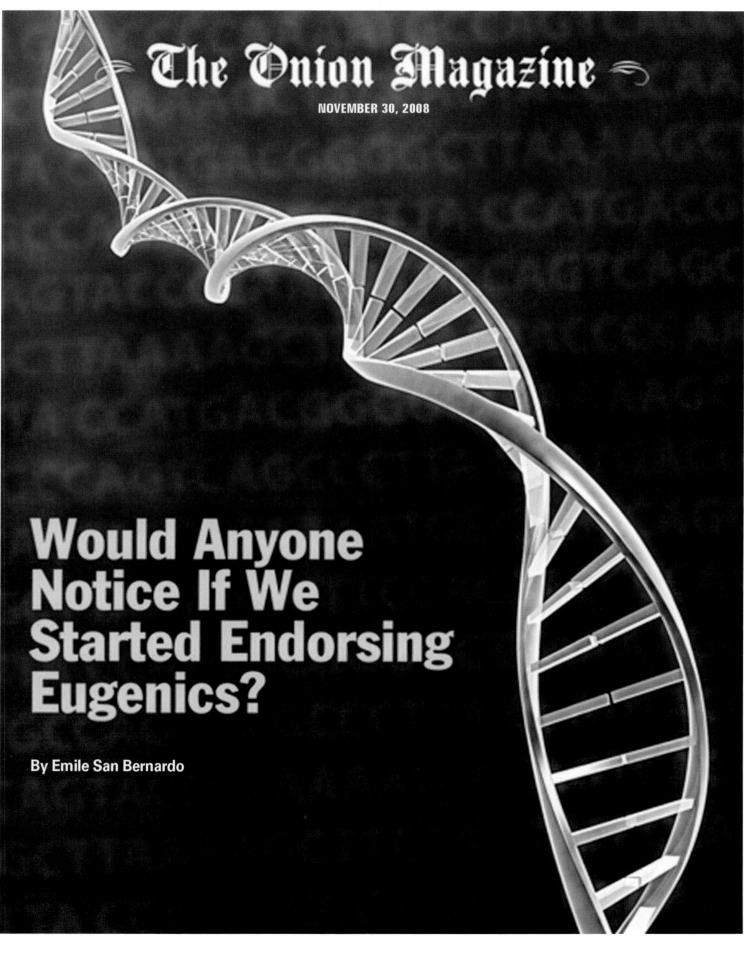

The Onion Magazine

NOVEMBER 30, 2008

Would Anyone Notice If We Started Endorsing Eugenics?

By Emile San Bernardo

WEEKENDER

DECEMBER 7, 2008

Holiday Gift Guide

50

Things For Your Sister That Look Like They Might Cost $75

But Are Actually Promotional Items For Opening Credit Cards

INSIDE Chronic Fatigue Syndrome: Could Screaming 'Wake The Fuck Up' Help?

We Think This Guy Might Seriously Be
The Real Santa Claus

AN ONION MAGAZINE SPECIAL REPORT *By Heath Driscoll*

ONION **WEEKENDER**

JANUARY 11, 2009

Are You Emasculating Your Boyfriend?

Make Him Take Our Quiz Page 25

INSIDE Six Hot New Ways To Break Your Arm!

103

ONION WEEKENDER

JANUARY 18, 2009

Slimming Down To Fit Into Your Super Bowl Outfit

Page 21

INSIDE **The Global Economic Collapse: Will It Build Character?**

ONION WEEKENDER

JANUARY 25, 2009

"I Take Myself To A Really Dark Place"

Michael Jordan Opens Up About Acting In Hanes Commercials

Page 27

INSIDE 101 Tips For Decommissioning An F-16

105

ONION WEEKENDER

What Are You Waiting For?

Somebody To Give You A Kiss, You Fucking Baby?

Page 27

INSIDE "Tuesday," "Reverse-Thursday," And Other Words For The Second Day Of The Work Week

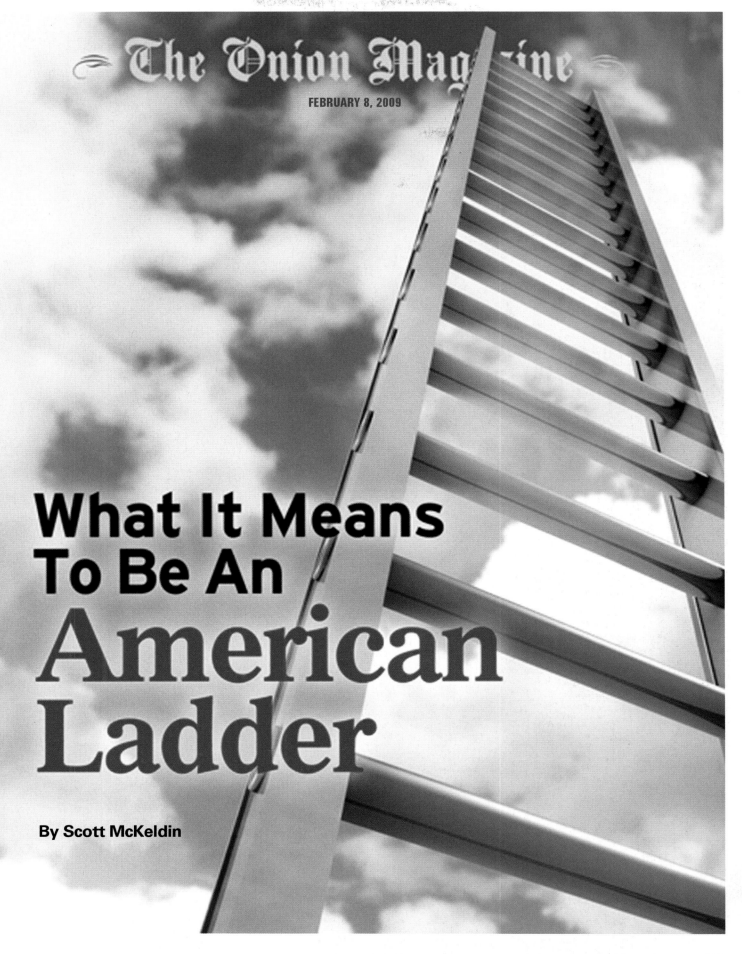

The Onion Magazine

FEBRUARY 8, 2009

What It Means To Be An American Ladder

By Scott McKeldin

ONION

WEEKENDER

FEBRUARY 15, 2009

THE ROMANCE ISSUE

Vigorously Rubbing The Head Of The Penis

And 10 Other Sex Tips

Page 18

INSIDE **The Metaphor John Updike Didn't Want You To See**

108

ONION WEEKENDER

We Take

10

Things You Like And Arrange Them In An Aesthetically Pleasing Grid

PAGE 27

INSIDE **How The New Great Depression Could Be Kinda Cool**

The Onion Magazine

MARCH 1, 2009

PRETTY BALLOONS

WHERE ARE THEY NOW?

BY CLARA LINWOOD

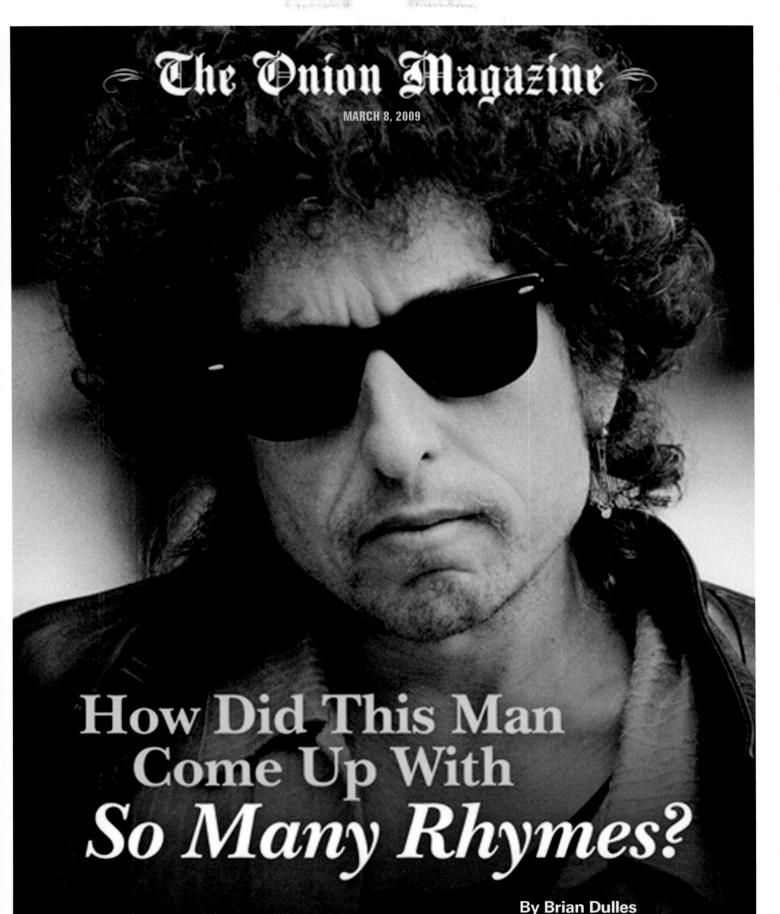

The Onion Magazine

MARCH 8, 2009

How Did This Man Come Up With So Many Rhymes?

By Brian Dulles

The Onion Magazine

MARCH 15, 2009

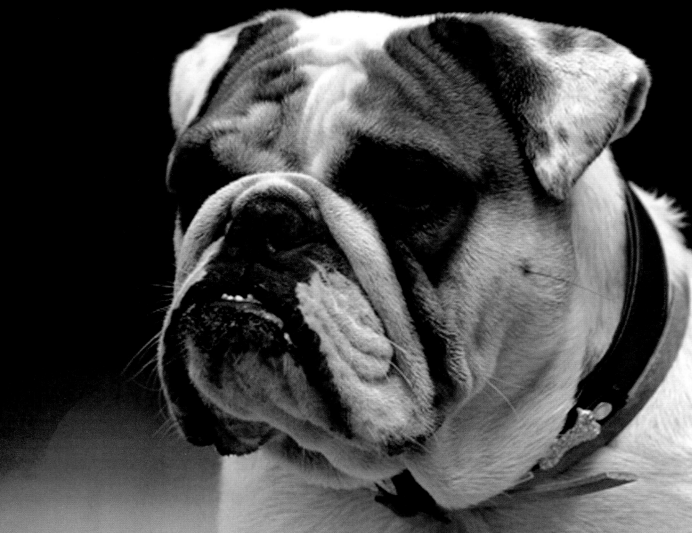

MEET TUG
The Dog Who Saved The Stimulus Package

By Aldon West

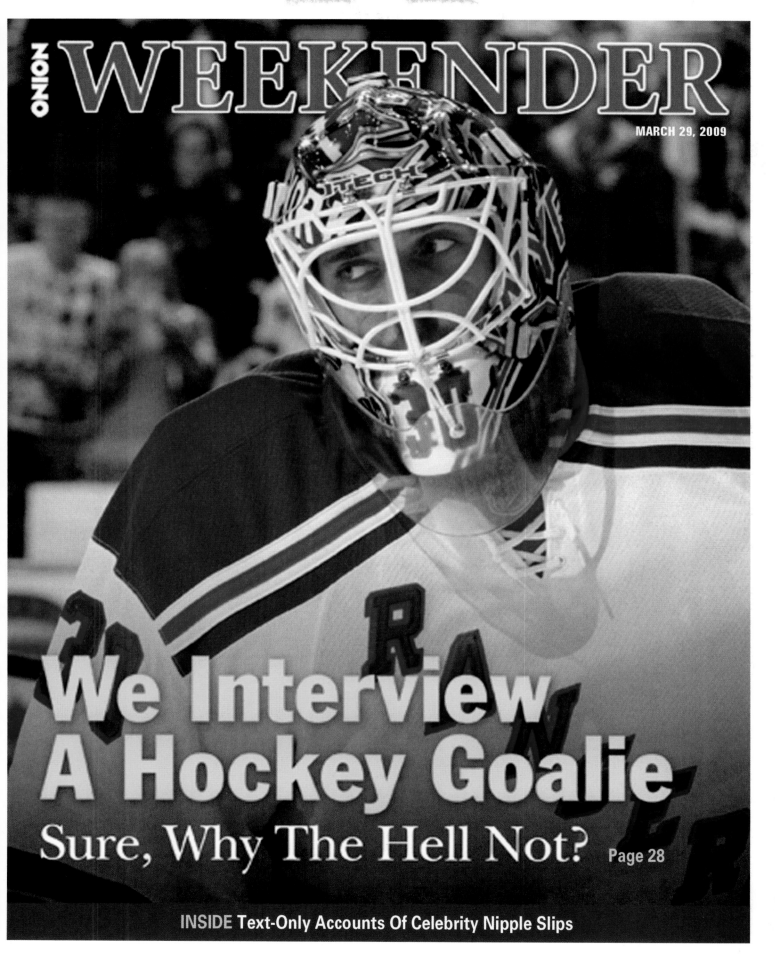

ONION
WEEKENDER

MARCH 29, 2009

We Interview A Hockey Goalie

Sure, Why The Hell Not?

Page 28

INSIDE Text-Only Accounts Of Celebrity Nipple Slips

WEEKENDER

APRIL 5, 2009

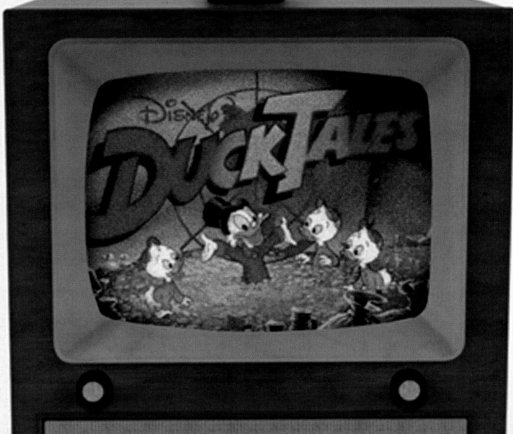

THE THEME SONG FROM DUCK TALES

And Why It's Now Stuck In Your Head

PAGE 28

INSIDE Coughing Your Way To Great Abs

ONION WEEKENDER

APRIL 12, 2009

The World's Most Terrifying HOOK

Page 17

Page 17

INSIDE Why Hasn't The Recession Hit The Mall's Creepy New Age Silver Store?

APRIL 19, 2009

GOING TOO FAR

HOW FAR IS IT?

IS THIS TOO FAR?
Because We Don't Think It Is.

By Eddie York

The Onion Magazine

MAY 10, 2009

Kansas
Sixth-District
Freshman
Alderman
ALAN KLEMKE

THE FIRST 100 DAYS

By Eugenia Dartmouth

117

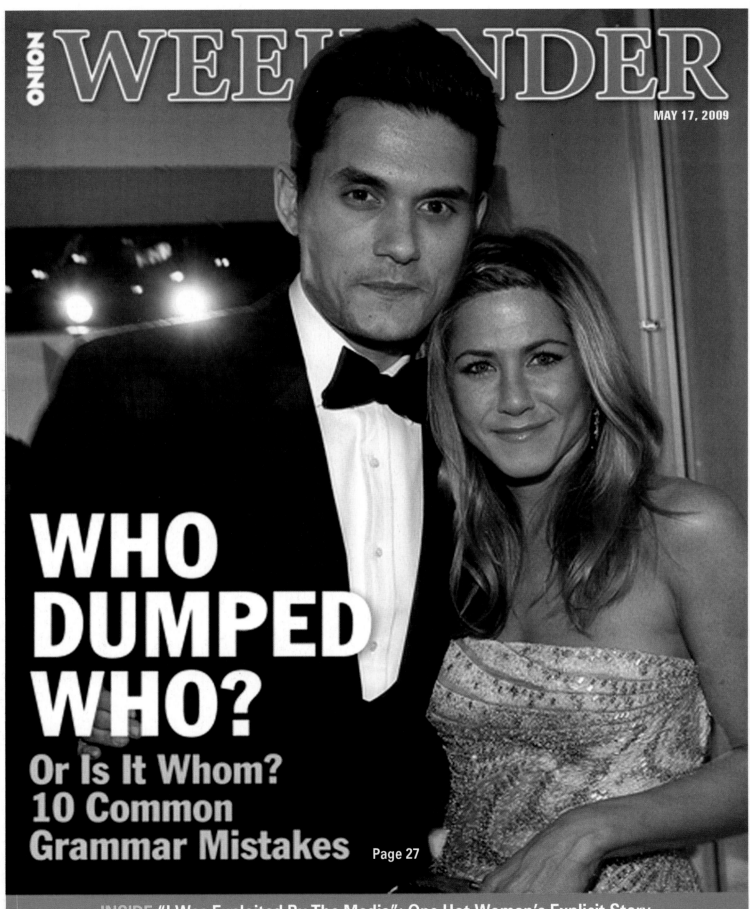

ONION

WEEKENDER

MAY 17, 2009

WHO DUMPED WHO?
Or Is It Whom?
10 Common
Grammar Mistakes
Page 27

INSIDE "I Was Exploited By The Media": One Hot Woman's Explicit Story

118

ONION **WEEKENDER**

MAY 24, 2009

How *Princess Diana* Would Be Staying Fit At 47

Page 32

INSIDE That Guy Who Had Those Cool Pair Of Oakley's In High School: Do You Think He Still Has Them?

119

We Regret *Asking Americans To Talk About* Faith

Page 29

LOOK AT THIS MESS

Just Look At It! How Did This Happen?

PAGE 20

INSIDE Five New Gulps That Could Take Up To 10 Minutes Off Your Meal Time

The Onion Magazine

JUNE 14, 2009

ANTS

Ants, Ants, Ants, Ants, Ants,
Ants, Ants, Ants, Ants, Ants,
Ants, Ants, Ants, Ants, Ants
Ants, Ants, Ants, Ants, Ants,
Ants, Ants, Ants, Ants, Ants,
Ants, Ants, Ants, Ants, Ants

PAGE 35

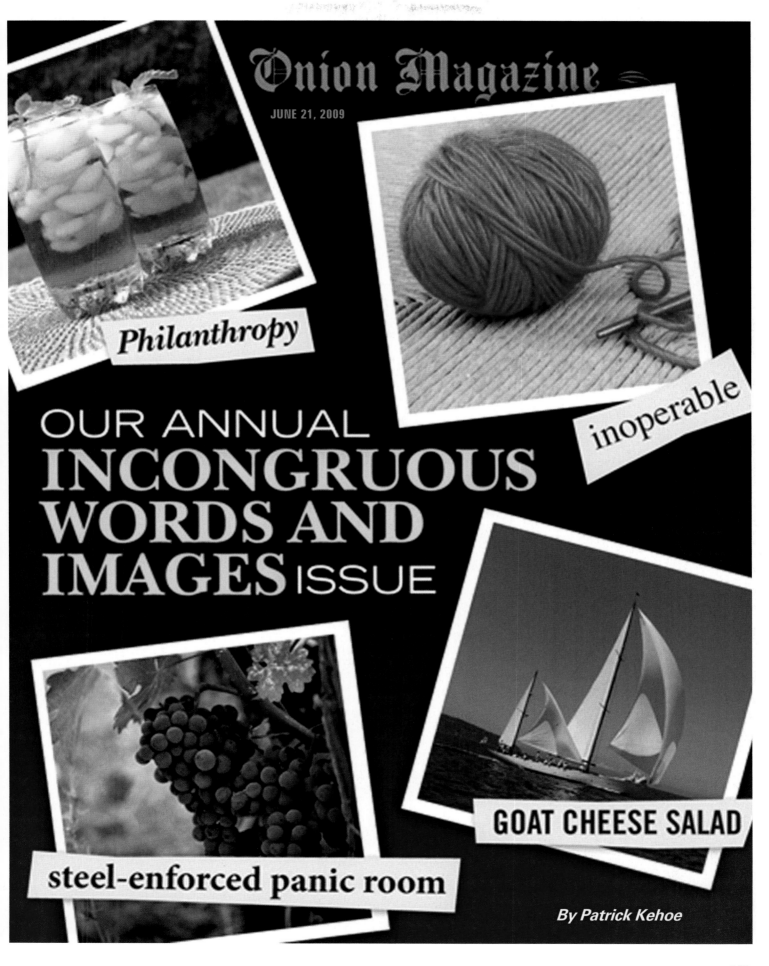

Onion Magazine

JUNE 21, 2009

Philanthropy

inoperable

OUR ANNUAL
INCONGRUOUS WORDS AND IMAGES ISSUE

GOAT CHEESE SALAD

steel-enforced panic room

By Patrick Kehoe

The Onion Magazine

JULY 12, 2009

TALKING TO YOUR KIDS ABOUT DEATH

FIVE EASY PLACES TO LEAVE THIS MAGAZINE LYING AROUND

By Joel LaRusso

124

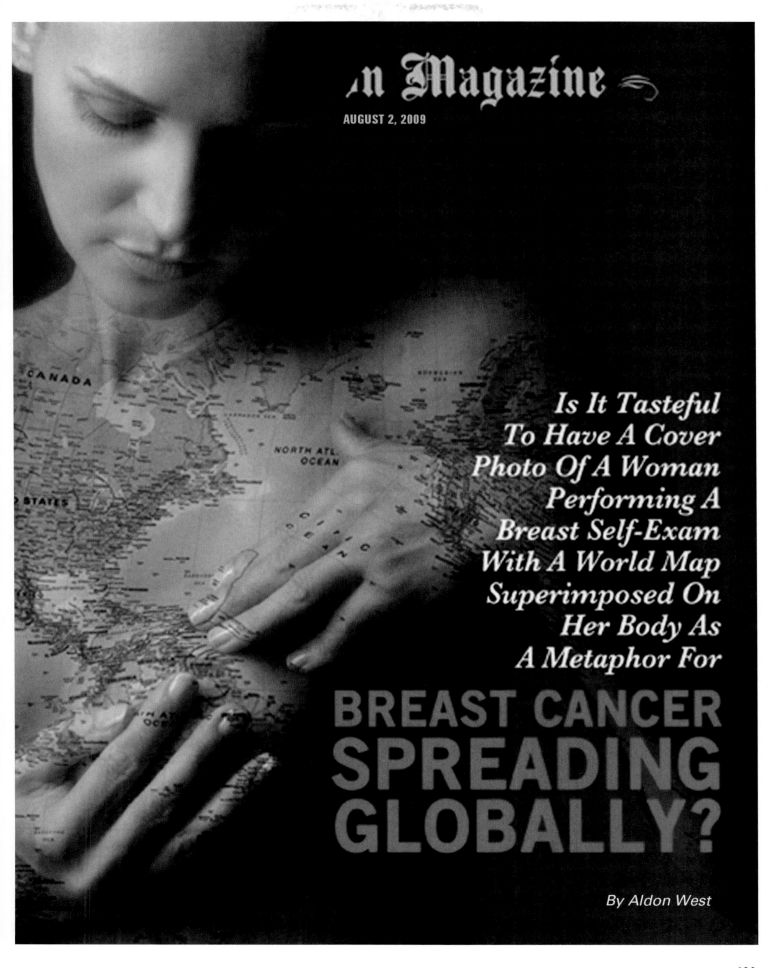

n **Magazine**

AUGUST 2, 2009

CANADA

NORTH ATL.
OCEAN

STATES

*Is It Tasteful
To Have A Cover
Photo Of A Woman
Performing A
Breast Self-Exam
With A World Map
Superimposed On
Her Body As
A Metaphor For*

BREAST CANCER SPREADING GLOBALLY?

By Aldon West

125

MICHAEL JACKSON'S MYSTERIOUS DEATH

Could Weird Al's Cruel Parody "Eat It" Be To Blame?

BY TRACY CAJAS

ONION WEEKENDER

SHINKENTO
The Hot New Number Puzzle Nobody Cares About
Page 18

INSIDE Look, This Isn't How We Wanted You To Find Out: Turn To Page 27

We Talk To Craig T. Nelson, Founder Of Craigslist

Page 28

INSIDE 10 Crude, Borderline Illegal Ways To Lose That Tummy

128

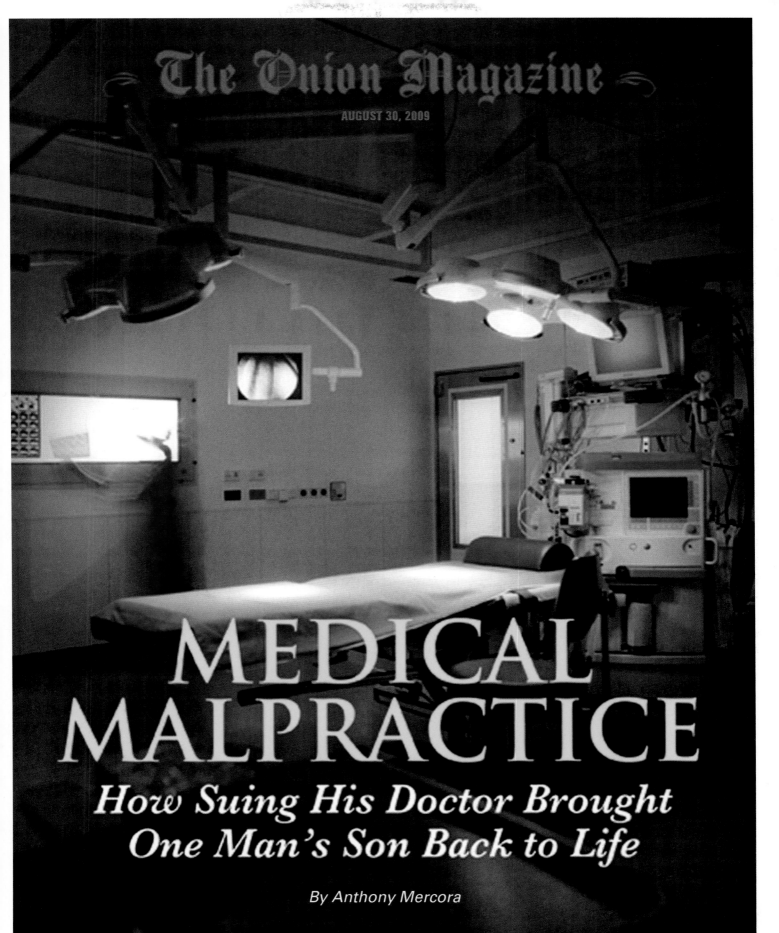

MEDICAL MALPRACTICE

How Suing His Doctor Brought One Man's Son Back to Life

By Anthony Mercora

The Onion Magazine

SEPTEMBER 13, 2009

AMERICA
IS IT WORTH THE EFFORT?

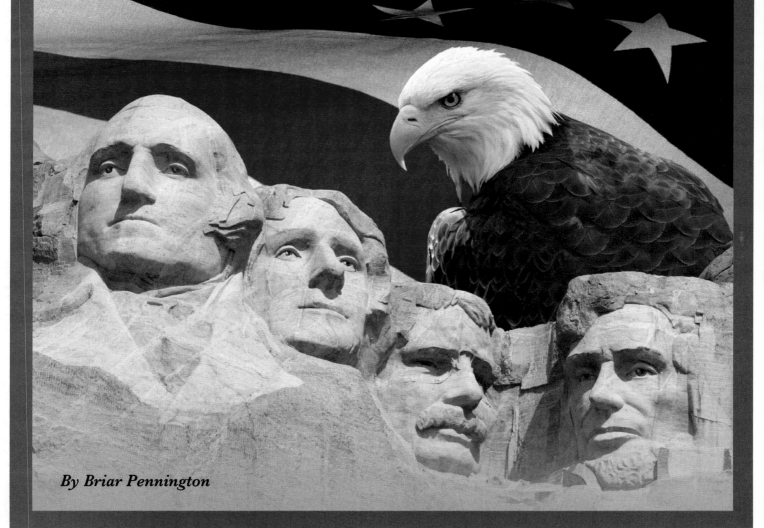

By Briar Pennington

Page 21

DOES THIS MAN KNOW

He's About To Get His Achilles Tendon Slashed?

INSIDE The Five U.S. Airports That Should Rock But Don't

131

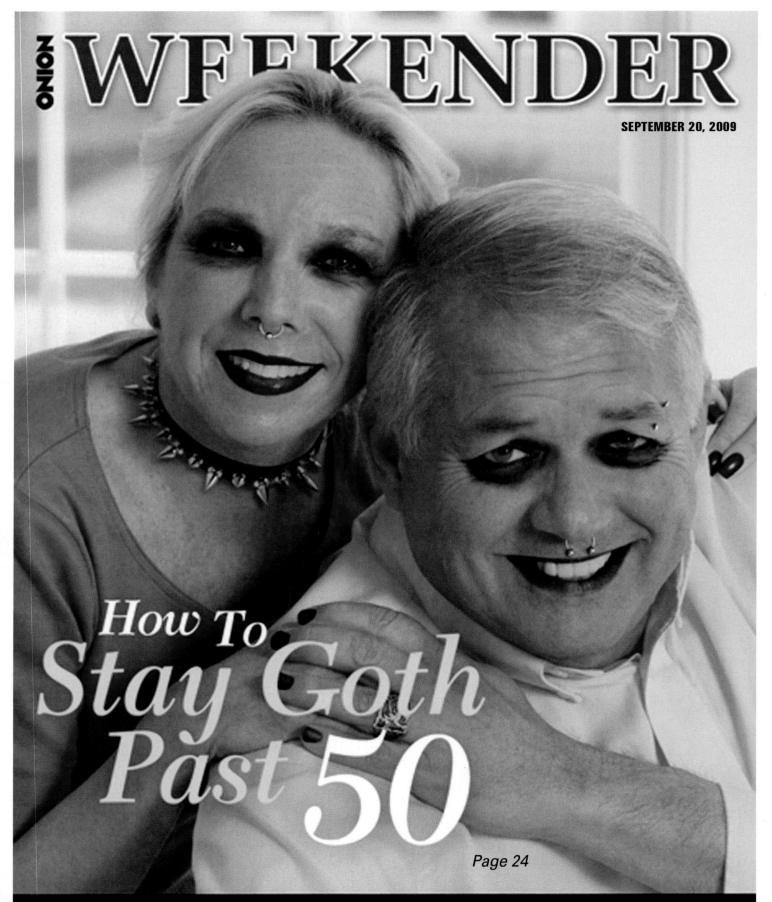

ONION

WEEKENDER

SEPTEMBER 20, 2009

How To
Stay Goth
Past 50

Page 24

INSIDE Your Website: We Finally Checked It Out. It's Not Very Good.

132

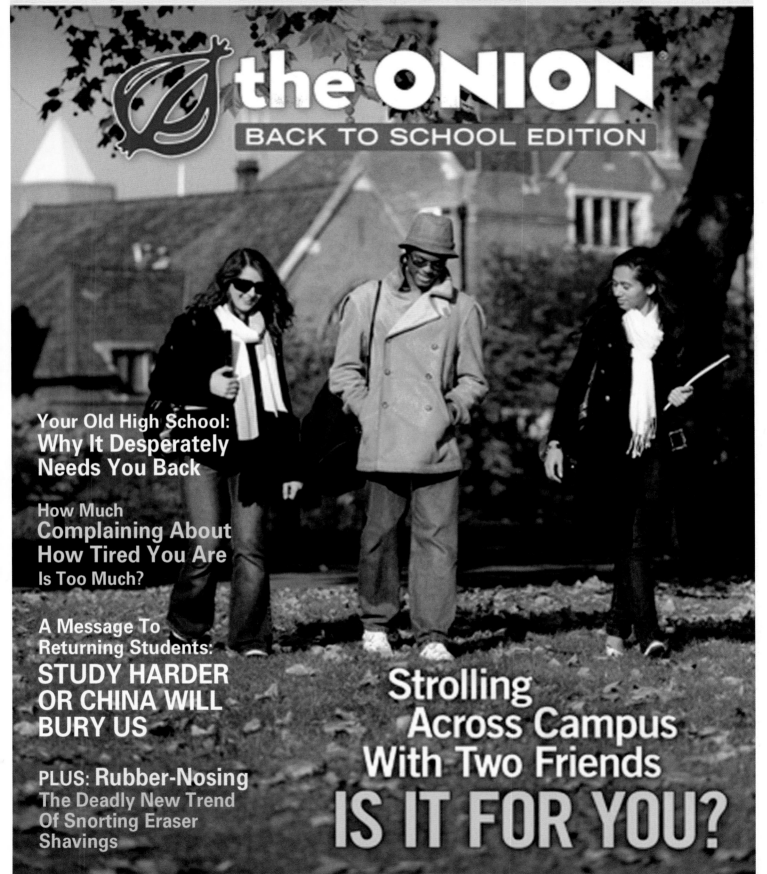

the ONION®

BACK TO SCHOOL EDITION

Your Old High School:
**Why It Desperately
Needs You Back**

How Much
**Complaining About
How Tired You Are**
Is Too Much?

A Message To
Returning Students:
**STUDY HARDER
OR CHINA WILL
BURY US**

PLUS: **Rubber-Nosing**
The Deadly New Trend
Of Snorting Eraser
Shavings

**Strolling
Across Campus
With Two Friends
IS IT FOR YOU?**

INSIDE: We Find Out What A Provost Does, And Quickly Forget

133

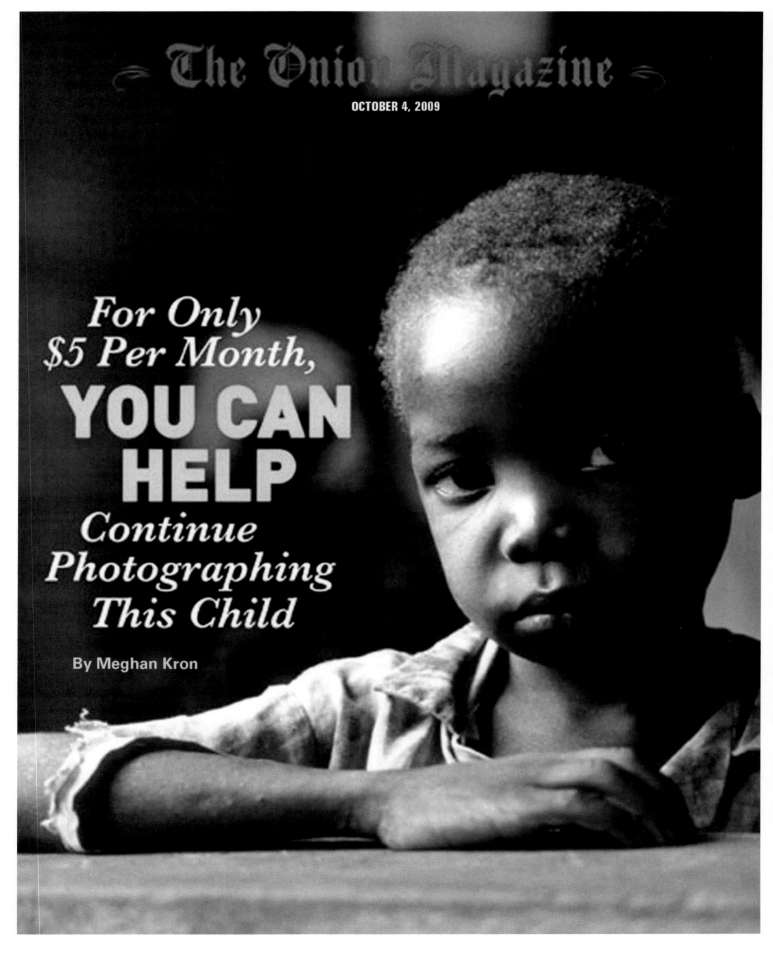

The Onion Magazine

OCTOBER 4, 2009

For Only
$5 Per Month,
YOU CAN
HELP
Continue
Photographing
This Child

By Meghan Kron

Our Own

PATRICK KEHOE

Writes Another Signature
Patrick Kehoe Article That Can't Be
Described In Just 8 or 10 Words.

Trust Us. It's Trademark Kehoe.

By Patrick Kehoe

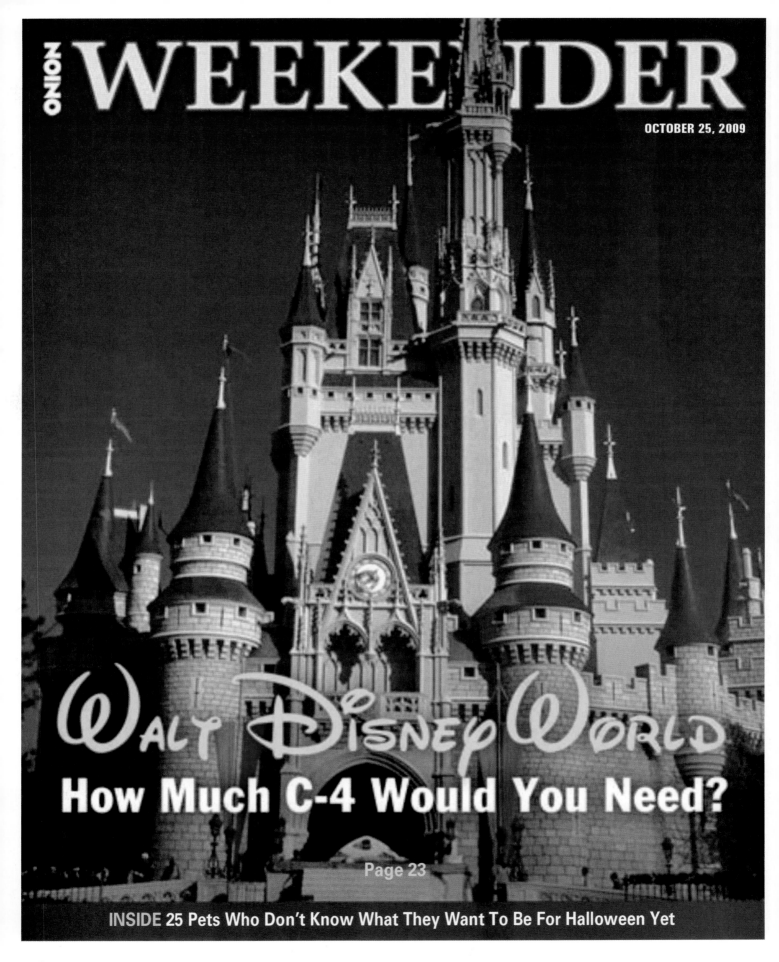

ONION WEEKENDER

OCTOBER 25, 2009

Walt Disney World
How Much C-4 Would You Need?

Page 23

INSIDE 25 Pets Who Don't Know What They Want To Be For Halloween Yet

136

ONION

WEEKENDER

BOO!

Why you were not remotely scared by this and how foolish we feel for even having tried Page 20

Page 20

INSIDE The Health Care Debate Settled In One 1,500-Word Article

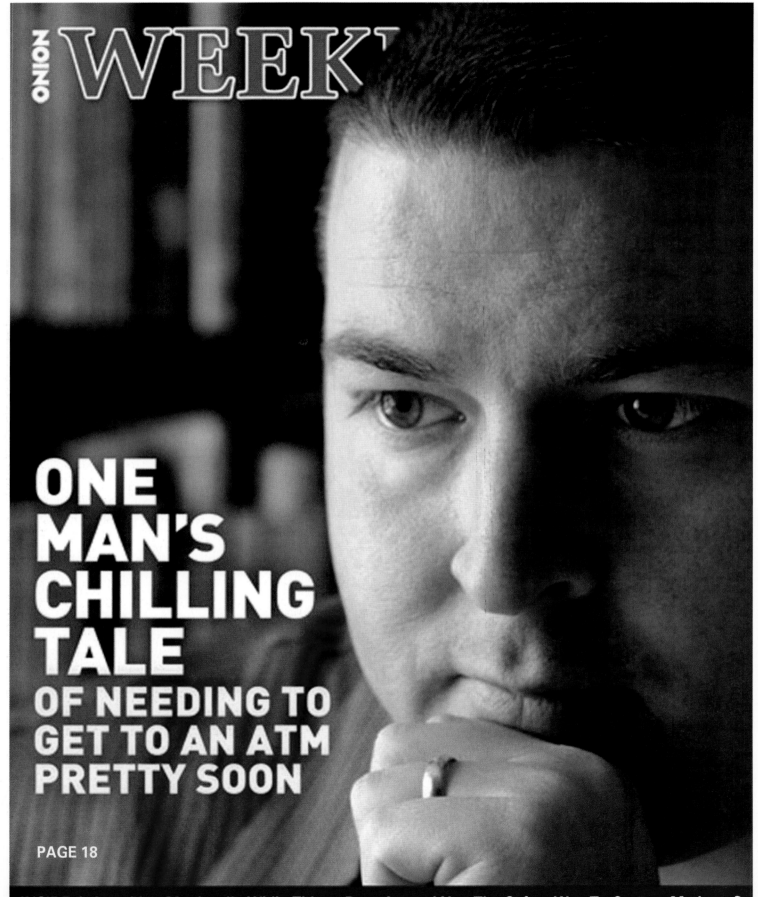

ONION WEEKL

ONE MAN'S CHILLING TALE
OF NEEDING TO GET TO AN ATM PRETTY SOON

PAGE 18

INSIDE Is Laughing Maniacally While Things Burn Around You The Safest Way To Convey Madness?

138

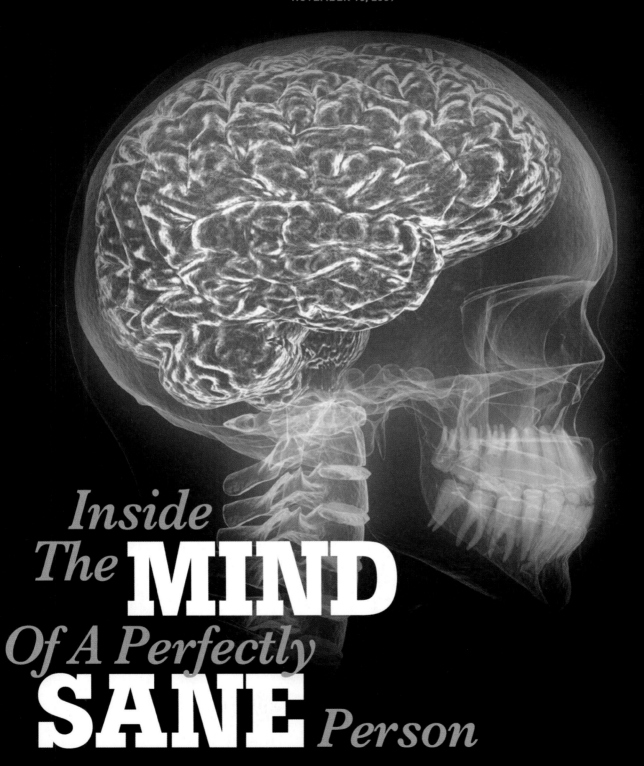

The Onion Magazine

NOVEMBER 15, 2009

Inside The MIND Of A Perfectly SANE Person

By Colin Worcester

The Onion Magazine

NOVEMBER 22, 2009

AIDS

After Nearly 30 Years, It Still Looks Pretty Intense When Written In All Red And Set Against A Black Background

By Meredith Archer

The Onion Magazine

NOVEMBER 22, 2009

INSIDE THE OBAMA WHITE HOUSE

Specifically The Air Conditioning Duct Near The West Wing

By Sabrina Moretti

ONION **WEEKENDER**

NOVEMBER 29, 2009

DOES ANYONE STILL HAVE A COPY OF LAST MONTH'S ISSUE?

We Need To Look Something Up

Page 24

INSIDE We Talk To Five People Who Look Like They Won't Be Upset If A Stranger Approaches Them

142

The Onion Magazine

DECEMBER 13, 2009

Three Eminent Biologists And *Growing Pains'* Kirk Cameron Weigh In On EVOLUTION

By Pavel Sokolov

The Onion Magazine

JANUARY 10, 2010

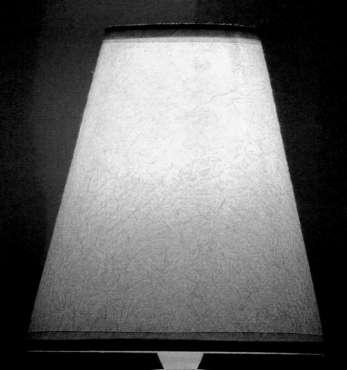

THIS LAMP

Is The Switch On The Cord Or By The Bulb?

By Jeff Hanley

The Onion Magazine

JANUARY 16, 2010

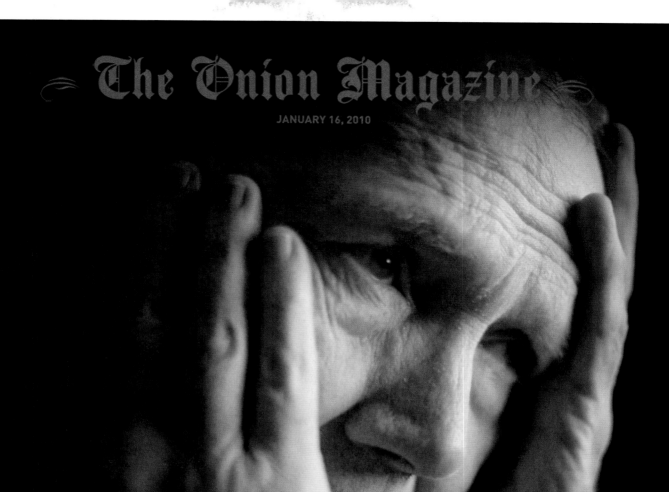

CHANGING THE WAY WE THINK ABOUT MENTAL ILLNESS

Anyone Really Up For Doing That?

By Thierry Laroche

The Onion Magazine

JANUARY 24, 2010

We Finally Get Around To Remembering TED KENNEDY

By James Giacco

ONION

WEEKENDER

JANUARY 24, 2010

SELF-DEFENSE TIPS
That Will Only Make Him Angrier Page 23

INSIDE The Nation's Top 10 Cincinnatis

147

THE ONION

JANUARY 31, 2010

weekender

Our **MOST** *Frustrating* **RedesigN** *ever*

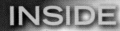

INSIDE

Life So Far
In The Post-
Brooks-And-
Dunn Era

ONION

WEEKENDER

FEBRUARY 14, 2010

Hey All You 'Bill Me Later' Motherfuckers

Guess What Today Is?

WEEKENDER

Discount Renewal Offer

YES! Renew me for 112 issues of
billed in 4 monthly installments — at 62%, ...
...tinue sending my
billed in 4 monthly installments – 17%, ...

Magazine subscription...

...Fill out your information below...

INSIDE We Call Michael Chabon A 'Jewish Author' In A Certain Tone

149

What Will
HUMANS LOOK LIKE
Six Months From Now?

By Taylor Basile

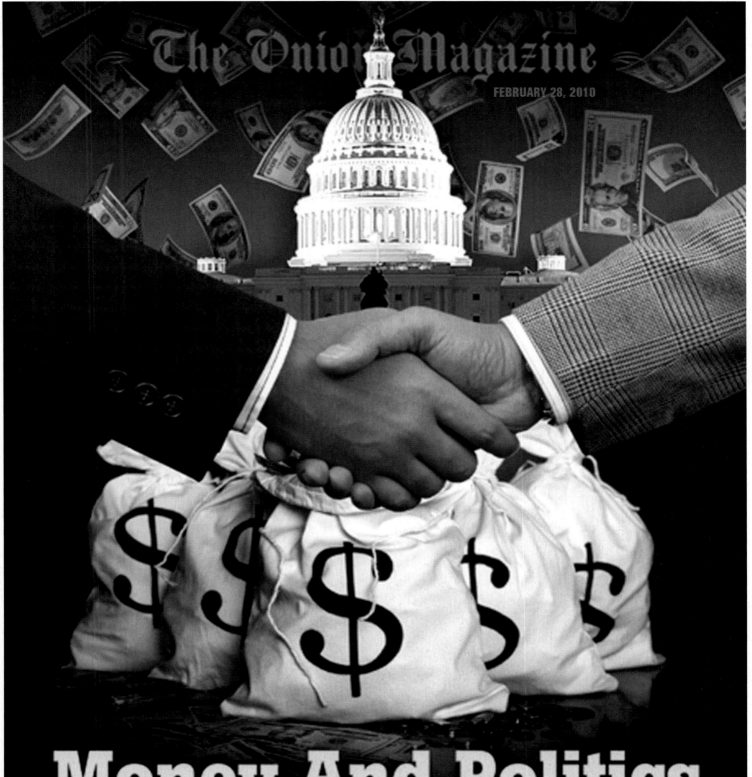

The Onion Magazine

FEBRUARY 28, 2010

Money And Politics
Are They Somehow Connected?

By Tracy Cajas

WHAT *Your Doctor* ISN'T *Telling You* ABOUT SAMMAEL, THE SEDUCER AND DESTROYER

Page 17

INSIDE 10 Home Improvement Tips That Will Really Fuck Over The New Owners

152

ONION WEEKENDER

MARCH 21, 2010

We Almost Go Inside

THE MIND OF TIM BURTON

But Then We Were Like 'Eh'

PAGE 24

INSIDE The Tedious Underbelly Of The Aluminum Siding Industry

153

The Onion Magazine

MARCH 28, 2010

How Gay Should Your *Husband* Be Before You File For *Divorce?*

By Jonathan Coleman

ONION WEEKENDER

APRIL 4, 2010

Are These Guys THIRD EYE BLIND?

PAGE 17

INSIDE **How Many Months' Unemployment Should You Spend On An Engagement Ring?**

155

ONION

WEEKENDER

APRIL 18, 2010

What Can This LUMBERJACK Teach Us About OVARIAN CANCER?

The Photographer Who Fucked Up His Assignment Better Hope It's Plenty

PAGE 18

INSIDE 10 Worthless Scumbag Snitches Who Made A Difference

156

The Onion Magazine

MAY 2, 2010

OUR 3-D Punctuation Issue

Free Glasses

PAGE 24

ONION

WEEKENDER

MAY 9, 2010

20 *tips*
For Turning Ordinary Jell-O Into Jell-O With Cool Whip On It

Page 18

INSIDE Our Most Terrifying Mother's Day Pranks

The Onion Magazine

MAY 23, 2010

Ecollectualism, Femmigration, Evangelitism.

We Combine Arbitrarily Paired **BUZZWORDS** & Comment On Them As Social Phenomena

ONION WEEKENDER

JUNE 6, 2010

THE GREAT WHITE SHARK

What To Know Before You Adopt

160

ONION

WEEKENDER

JULY 18, 2010

A Special Issue Guest-Proofread By

BONO

INSIED Renewing Your Vows And 10 Other Signs Your Marriage Is Over

162

The Onion Magazine

AUGUST 1, 2010

Are Physical Events TRULY INDIVIDUATED On The Basis Of Spatio-Temporal Localization, *Or Is This Merely A* CONVENIENT ONTOLOGICAL MODE OF EVADING The Influence Of CAUSAL POWERS ?

PART 4 OF A 6-PART SERIES BY CLIVE MCKIBBIN

ONION WEEKENDER

AUGUST 8, 2010

How You Can INSTANTLY INCREASE YOUR IQ

By Standing In Front Of A Nice Bookshelf

INSIDE 10 Ways To Make God Notice You

164

THE ONION

WEEKENDER

AUGUST 15, 2010

10 ways
To Beat The Quadruple Amputation Blahs

INSIDE 5 New Genders The Government Doesn't Want You To Know About

165

ONION

WEEKENDER

AUGUST 22, 2010

Two Quarter-Full Wine Glasses Left On A Table In Front Of A Sunset

& Other Ways To Indicate

That People Are Fucking In The Other Room

166

ONION

WEEKENDER

AUGUST 29, 2010

IT'S OFFICIAL!

PAGE 18

INSIDE 10 Ways To Make The Most Of It!

ONION **WEEKENDER**

SEPTEMBER 5, 2010

Don't Show This Cover To Your Wife

Unless You Want Your Living Room To Look

Exactly Like This

INSIDE Top 10 Places To Live If You've Pretty Much Given Up

168

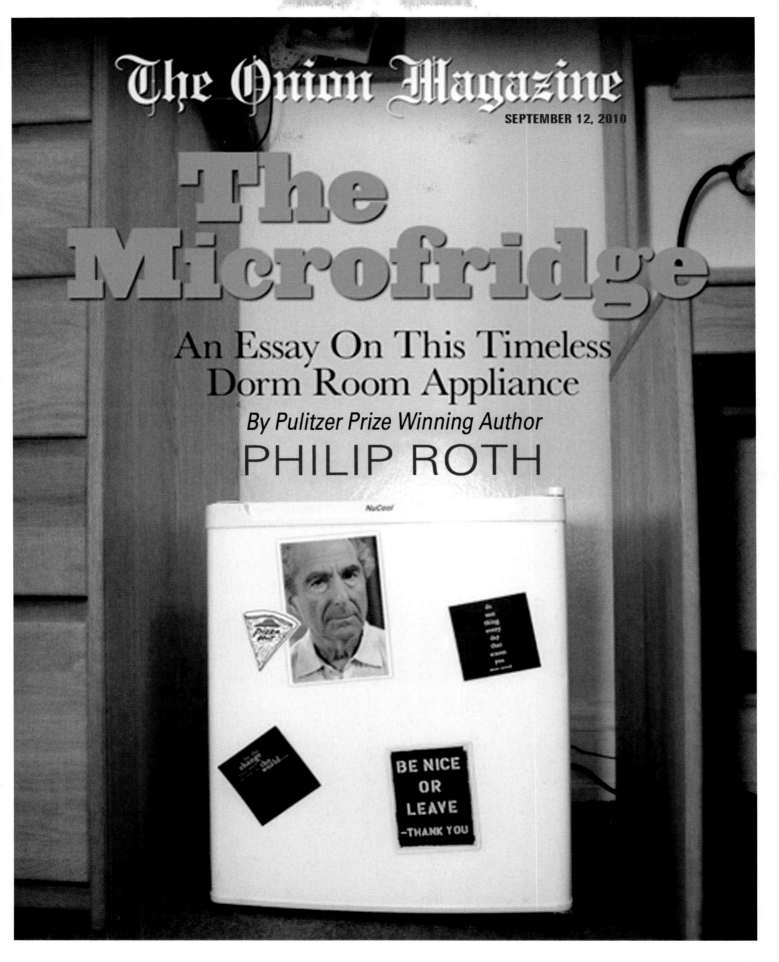

The Onion Magazine

SEPTEMBER 12, 2010

The Microfridge

An Essay On This Timeless Dorm Room Appliance

By Pulitzer Prize Winning Author

PHILIP ROTH

BE NICE
OR
LEAVE
–THANK YOU

ONION WEEKENDER

SEPTEMBER 19, 2010

Fireflies, Bullfrogs

& *Other Cool Things*

You Can See In The Woods Near Our Cousin's House

INSIDE Five Charities That Will Give You A T-Shirt When You Donate

170

ONION WEEKENDER

SEPTEMBER 26, 2010

Are America's PR Firms Hiding THE NEXT POP SENSATION For Themselves?

INSIDE Can The Internet Justify Your Unsettling Fetish?

171

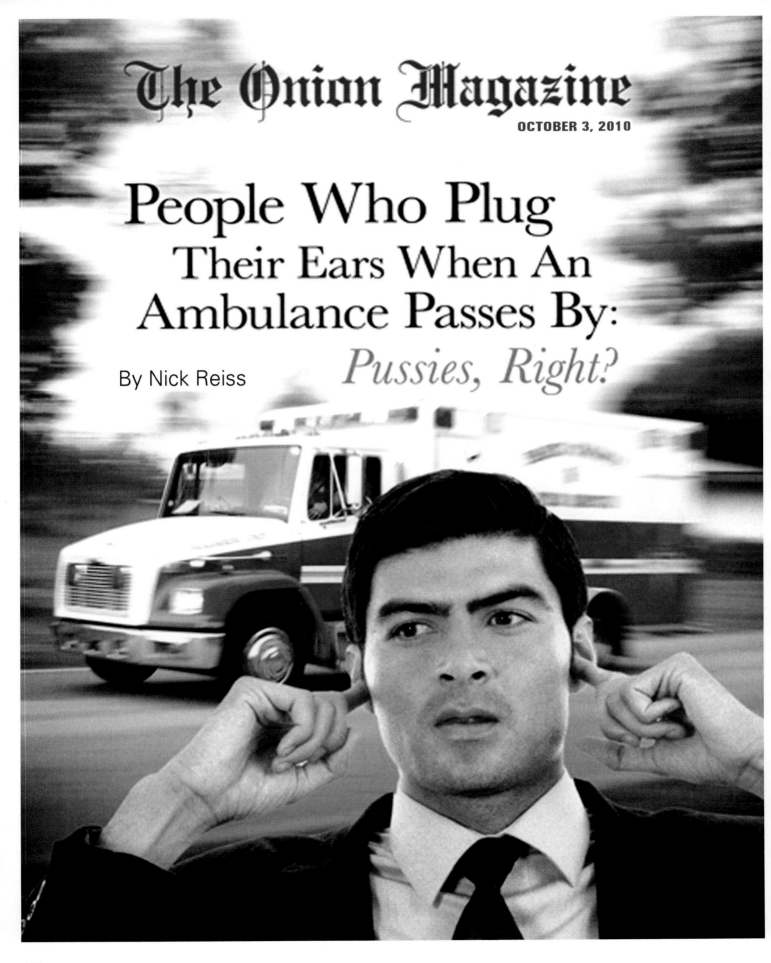

The Onion Magazine

OCTOBER 3, 2010

People Who Plug Their Ears When An Ambulance Passes By: Pussies, Right?

By Nick Reiss

The Onion Magazine

OCTOBER 10, 2010

The Life-Threatening

DANGERS

Of Trying On

Someone Else's Glasses

By Will Palmer

The Onion Magazine

OCTOBER 31, 2010

By Guy Guterman

Cut Along The Eye-holes To Make A Magazine-Cover *Mask!*

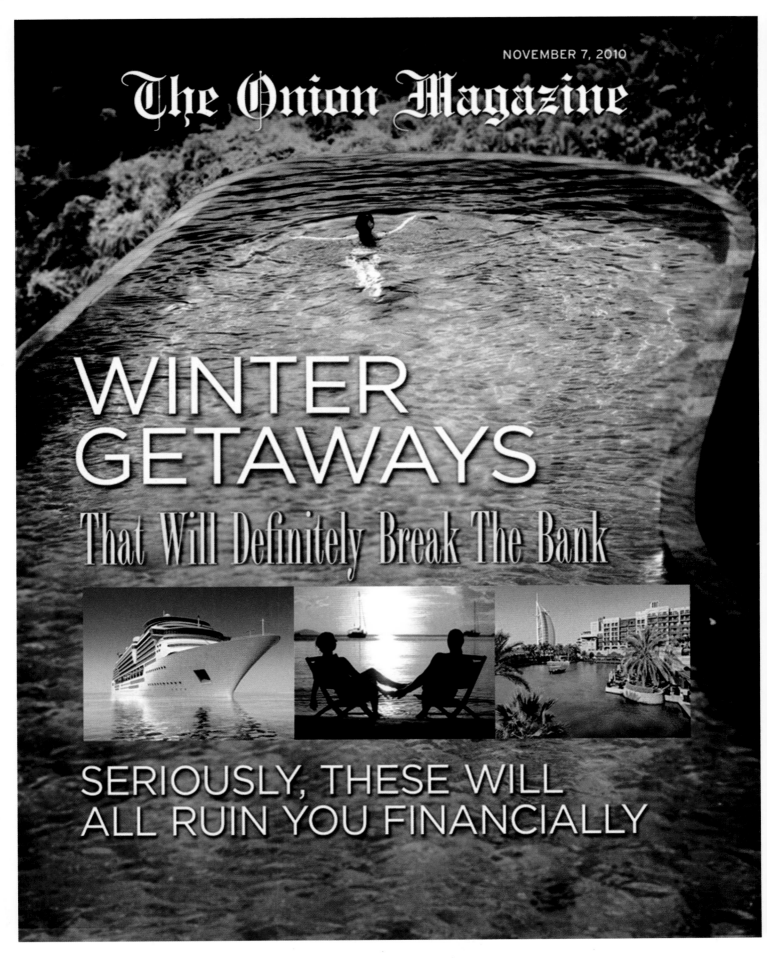

The Onion Magazine

WINTER GETAWAYS
That Will Definitely Break The Bank

SERIOUSLY, THESE WILL ALL RUIN YOU FINANCIALLY

ONION **WEEKENDER**

NOVEMBER 14, 2010

Mark?
Mark Hothan?

Oh My God, Is That You?

By Sharon Stevenston

INSIDE All The Stuff We Got With Loose Change Found In Other Peoples' Cars

The Onion Magazine

NOVEMBER 21, 2010

WE DECLARE MIDEAST PEACE

AND SEE IF IT STICKS

By Chauncey McMillan

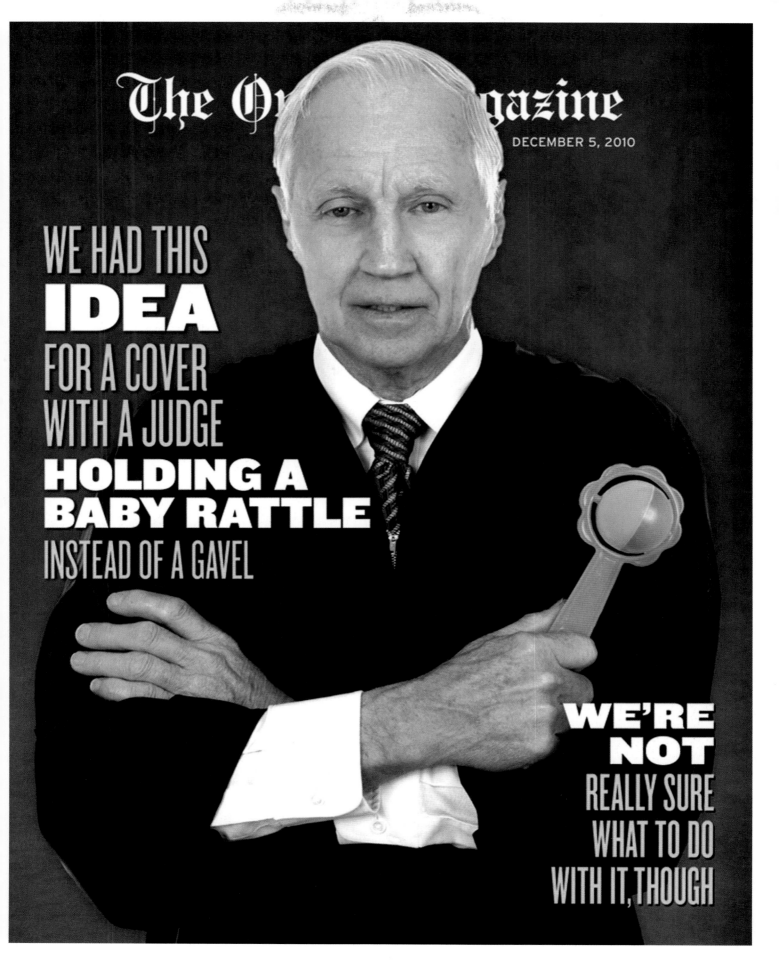

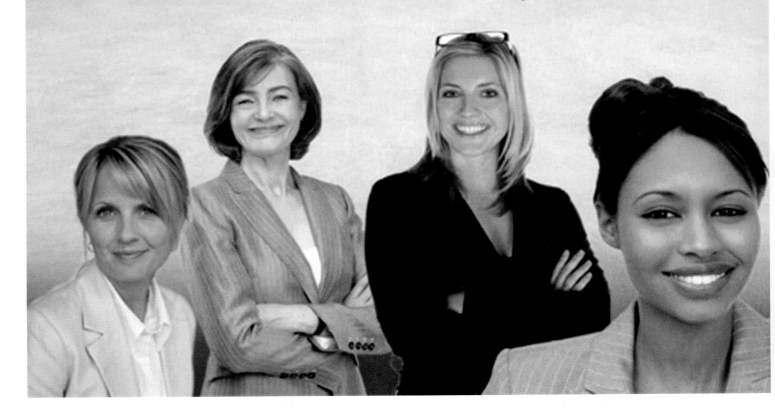

The Onion Magazine

DECEMBER 10, 2010

The World's 10 Most Powerful WOMEN

We Make Them Discuss Fashion And Lindsay Lohan

ONION WEEKENDER

JANUARY 16, 2011

How To Make YOUR OWN Fishing Lures *Without* Thinking About How Your Son Hasn't Spoken To You In 20 Years

By James
LaBonte

The Onion Magazine

JANUARY 23, 2011

CROCHET

What Role Does It Play In The Grandmotherization Of America?

The Onion Magazine

FEBRUARY 6, 2011

We're On To You.

We Don't Know What Your Angle Is Yet, But Rest Assured, We're Going To Find Out.

By Carmen Messina



ONION WEEKENDER, FEBRUARY 13, 2011

10 Parking Spots That Are Open RIGHT NOW If You Hurry

Bottom: INSIDE Reducing Your Risk Of Meeting Charlie Sheen



ONION WEEKENDER

FEBRUARY 13, 2011

10 Parking Spots That Are Open RIGHT NOW If You Hurry

INSIDE Reducing Your Risk Of Meeting Charlie Sheen

184

ONION **WEEKENDER**

FEBRUARY 20, 2011

Playing The
WAITING GAME
With Neil Young's Publicist

By Sheila Rivera

$25

The Onion Magazine

We Take You UNDERNEATH The Academy Awards

EXCLUSIVE
By Jackie Harvey

The Onion Magazine

>You Are Standing In An Open Field West Of A White House, With A Boarded Front Door; There Is A Small Mail Box Here

And Other Unforgettable Moments From ZORK 1

The Onion Magazine

If We Were In The Middle Of Another **GREAT** DEPRESSION Could We Afford A Cover Photo Like This?

ONION WEEKENDER

MARCH 20, 2011

How To Get Your **PREMATURE BABIES** *Into* **The Best Incubators**

INSIDE An Excerpt From Augusten Burroughs' New Memoir That We Were Paid To Run

189

$25

The Onion Magazine

EVERYTHING BAGEL WITH CREAM CHEESE AND TOMATO

Did You Want That For Here Or To Go?

ONION WEEKENDER

APRIL 10, 2011

10 Tips
To Really
Increase
Your Back Pain

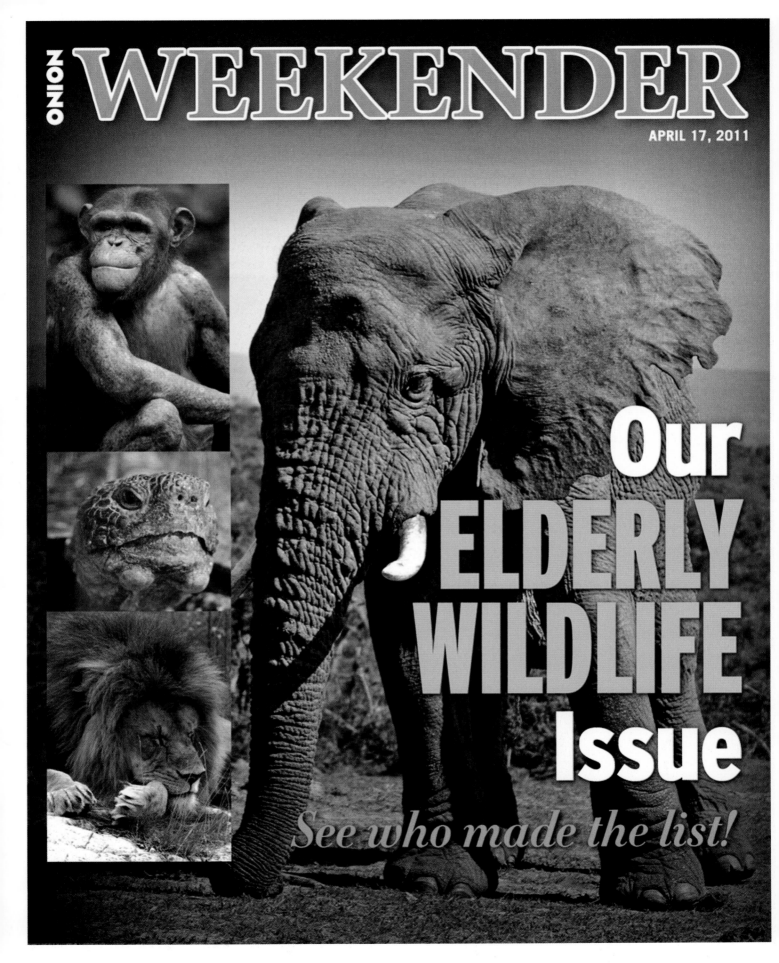

ONION WEEKENDER

APRIL 24, 2011

It's Aunt Lisa's Birthday Today

Please Give Her A Call When You Get Home From Work

By Grace Malone

ONION WEEKENDER

MAY 1, 2011

30 TREES UNDER 300 To Watch

The Onion Magazine

Here Comes

PRINCESS DIANA 2.0!
PALACE INSIDERS
On The

ROYAL WEDDING
From Bachelor Party to Bridal P

CIVIL WAR *at* GOLDMAN SACHS
By WILLIAM D. COHAN
P. 168

OUR ANNUAL VANITY FAIR ISSUE

ROB LOWE
CONFESSES

RUNNING WILD with **CHARLIE SHEEN,**
SEAN PENN, MATT DILLON, *and the*
NIGHT HE SHARED A BED with **TOM CRUISE**
A Very Candid Memoir About Making It in Hollywood
Photos by ANNIE LEIBOVITZ
P. 180

"A boy's story is the
best that is ever told."
–CHARLES DICKENS

MAY 2011

195

ONION

WEEKENDER

JUNE 5, 2011

The **POLISH** *Selena*
Fresh Out Of Rehab & High On Life

ONION

WEEKENDER

JUNE 12, 2011

Sticks Found In The Woods

COULD THEY BE WORTH SOMETHING?

WHOA, What Did That Guy Order?

ONION WEEKENDER

JULY 17, 2011

We Placed A CLEAN SHEET OF GLASS

Somewhere Across This Woman's Jogging Route

$25

The Onion Magazine

What Would You Do If You Saw A Mouse On An Airplane?

Be Pretty Weird, Wouldn't It?

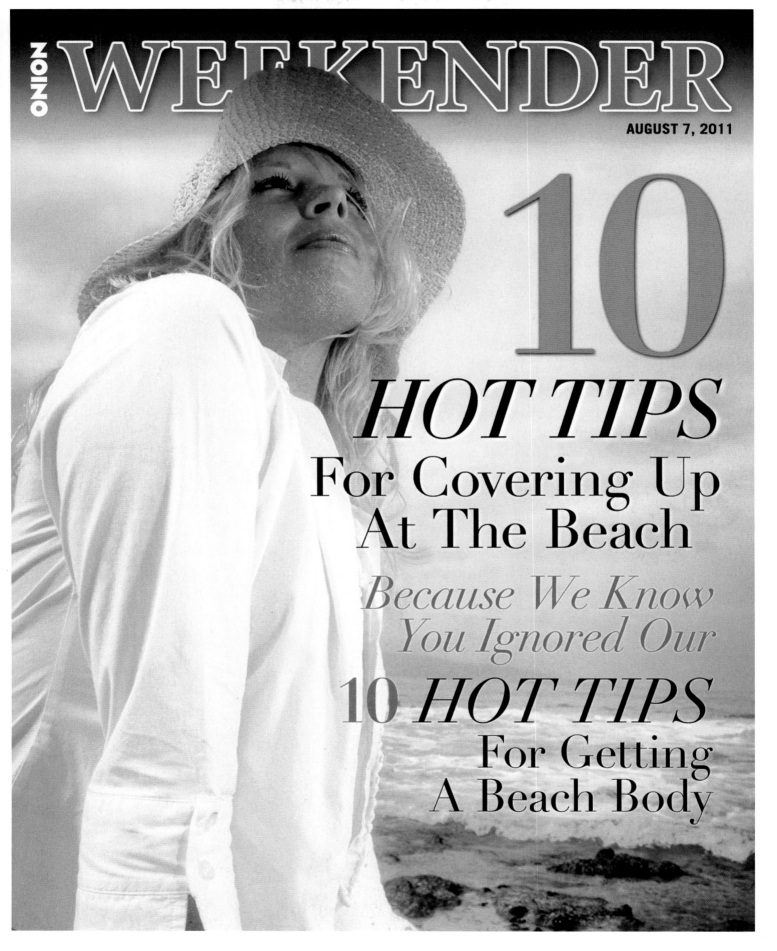

ONION

WEEKENDER

AUGUST 7, 2011

10

HOT TIPS
For Covering Up
At The Beach

*Because We Know
You Ignored Our*

10 *HOT TIPS*
For Getting
A Beach Body

201

$25

The Onion Magazine

We Take You Inside The Bizarre World Of 'COMPETITIVE ATHLETICS,' Or 'Sports'

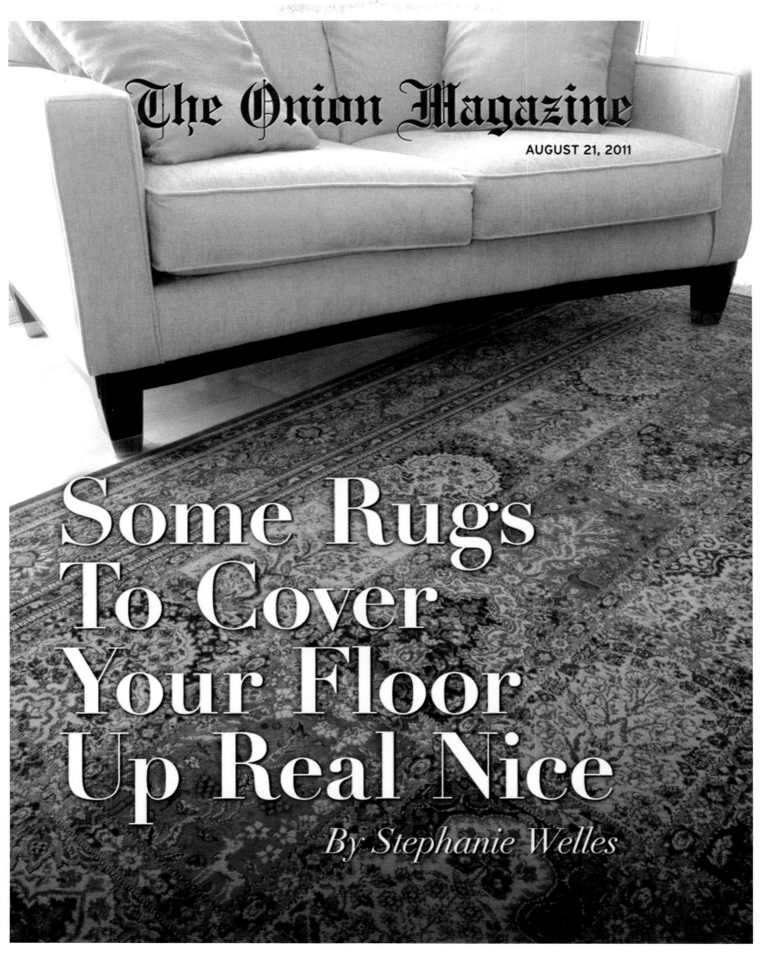

The Onion Magazine

AUGUST 21, 2011

Some Rugs To Cover Your Floor Up Real Nice

By Stephanie Welles

ONION

VEEKENDER

AUGUST 28, 2011

What Was Your First Concert?

Ours Was Queensrÿche In '89

204

ONION **WEEKENDER**

SEPTEMBER 11, 2011

SEPTEMBER 11TH REMEMBERED

'I Was Supposed To Fly From Tampa To Atlanta On 9/11'

One Printing Consultant Shares His Story

205

ONION

WEEKENDER

OCTOBER 23, 2011

CLASSIC LOOKS *For*
40-SOMETHING WOMEN
Married For The Second Time And
TRYING TO GET PREGNANT

10 CELEBRITIES Who Just Wanted To Eat In Peace

206

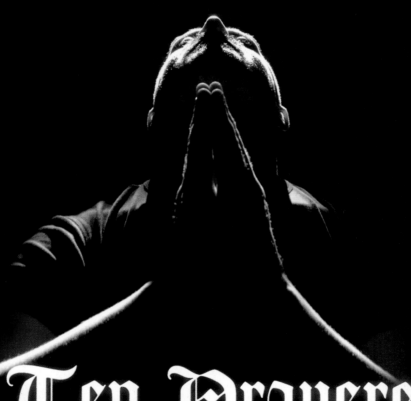

The Onion Magazine

Ten Prayers
That Will Get God To Stand Up And Take Notice

THE MOST IN-DEMAND SLEEPOVER BUDDIES

For The Greater Lincoln City Metropolitan Area

DECEMBER 9, 2011

$25

The Onion Magazine

COFFEE TABLES

If The Thought Of Them Made You Read This Far,

Do You Really Want To Live?

INSIDE: LIVING IN A POST-SHIRT AMERICA

ONION WEEKENDER

101 *Ways*
To Drive Your
BEST FRIEND
Wild

INSIDE:
*How To Ward Off
Alzheimer's Patients*

210

The Onion Magazine

Are
BUGS
MAD
At Us?

211

FEBRUARY 3, 2012

ONION | WEEKENDER

TOMMY LEE JONES

Tells Us Why He's Kept A **Little Boy's Name** *For So Long*

INSIDE: TAKING ONE FOR THE TEAM: *Why You Shouldn't Ever Do That*

ONION WEEKENDER

STARTLING PIGEONS

AND *16* OTHER USES FOR A *Trombone*

The Onion Magazine

IF PUSHING THIS BUTTON MADE YOU A BILLIONAIRE BUT ALSO KILLED A RANDOM STRANGER, WOULD YOU DO IT?

We Would. *We Did.*

ONION WEEKENDER

TOP 10 PUSHOVERS

AND HOW WE GOT THEM TO DO THIS Photoshoot

INSIDE: *What Will Be The Sonnet Of The Summer?*

215

ONION

WEEKENDER

APRIL 6, 2012

THE COLOR ON THE LEFT OR THE RIGHT:

Which Do You Think Is Better For A Living Room Accent Wall?

ONION WEEKENDER

MAY 4, 2012

THE TOP 100 COMPANIES

That Aren't Hiring Right Now

But Will Keep Your Information On File

INSIDE: LOWERING YOUR HEATING BILL WITHOUT BURNING YOUR PETS FOR FUEL

MAY 18, 2012

ONION WEEKENDER

THAT ONE KID IN HIGH SCHOOL WHO HAD A HEARING AID:

We Check And See How Bad His Hearing Is Now

INSIDE: NOT GOING AND OTHER CHEAP VACATION IDEAS

218

MAY 25, 2012

ONION WEEKENDER

10 WAYS TO WOW
SLOVENIAN PHILOSOPHER
SLAVOJ ŽIŽEK
IN BED

INSIDE: SEVEN TRAVEL TIPS BASED ON THE ASSUMPTION YOU HAVE AN AUNT IN KEY WEST YOU COULD CRASH WITH

ONION WEEKENDER

JUGGLING:
YOU CAN TAKE PICTURES OF IT

INSIDE: 10 REASONS FOR STRESS YOU MAY HAVE OVERLOOKED

The Onion Magazine

THE ONION'S SALUTE
TO THE AMERICAN FATHER

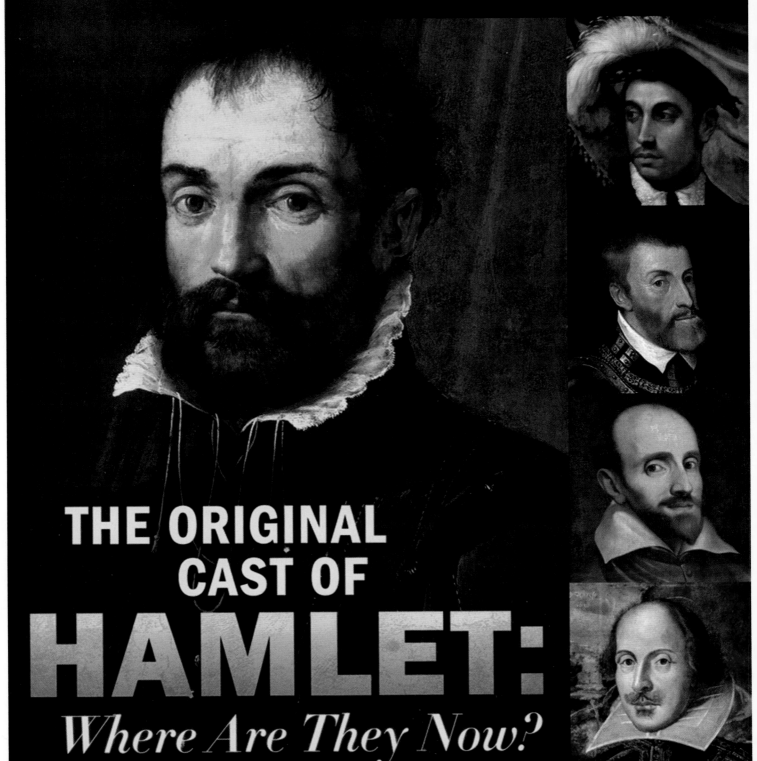

ONION

WEEKENDER

THE ORIGINAL CAST OF
HAMLET:
Where Are They Now?

INSIDE: 10 AFFORDABLE DAY TRIPS TO PLACES WHERE YOU COULD PROBABLY GET AWAY WITH ARSON

JULY 27, 2012

The Onion Magazine

Harness the Power of
RUBBING
YOUR TEMPLES

The Onion Magazine

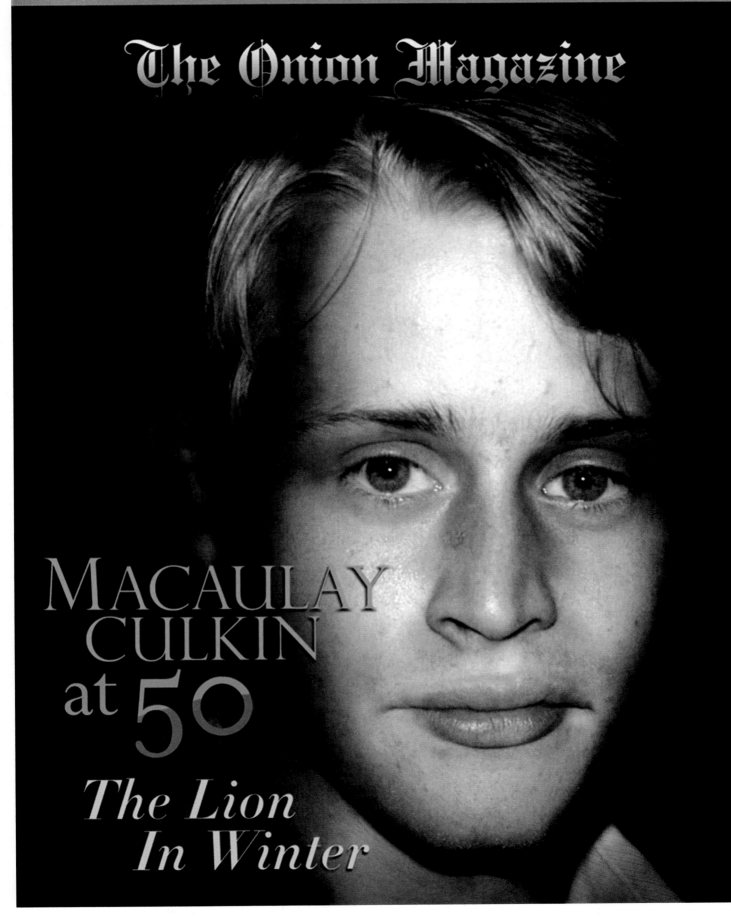

MACAULAY CULKIN at 50

The Lion In Winter

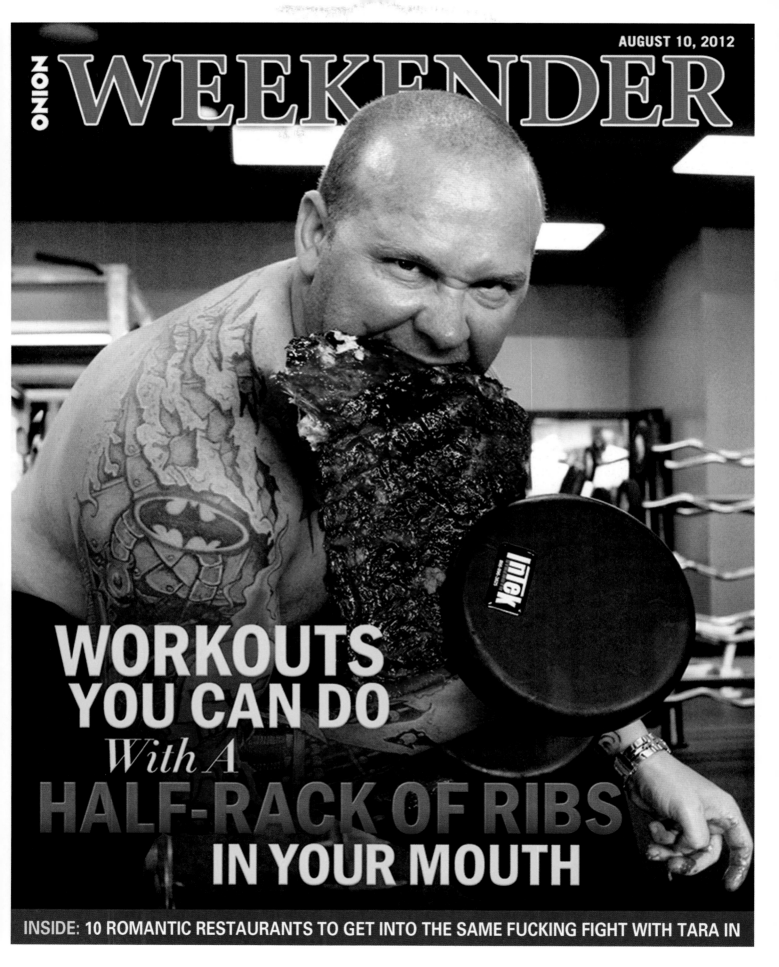

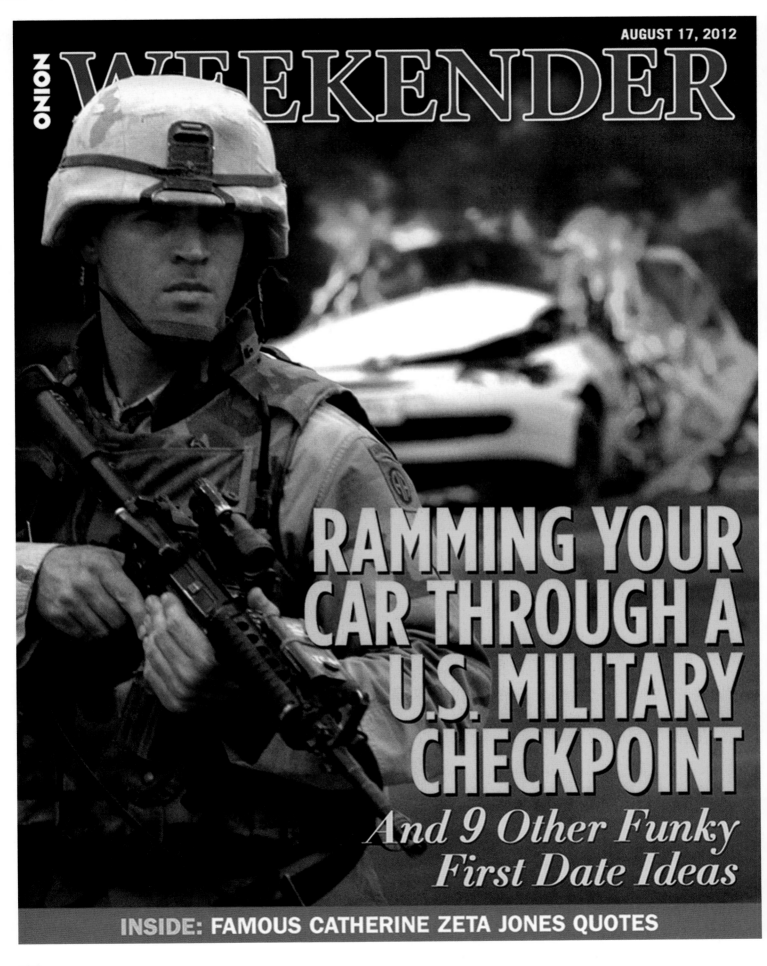

AUGUST 17, 2012

ONION

WEEKENDER

RAMMING YOUR CAR THROUGH A U.S. MILITARY CHECKPOINT

And 9 Other Funky First Date Ideas

INSIDE: FAMOUS CATHERINE ZETA JONES QUOTES

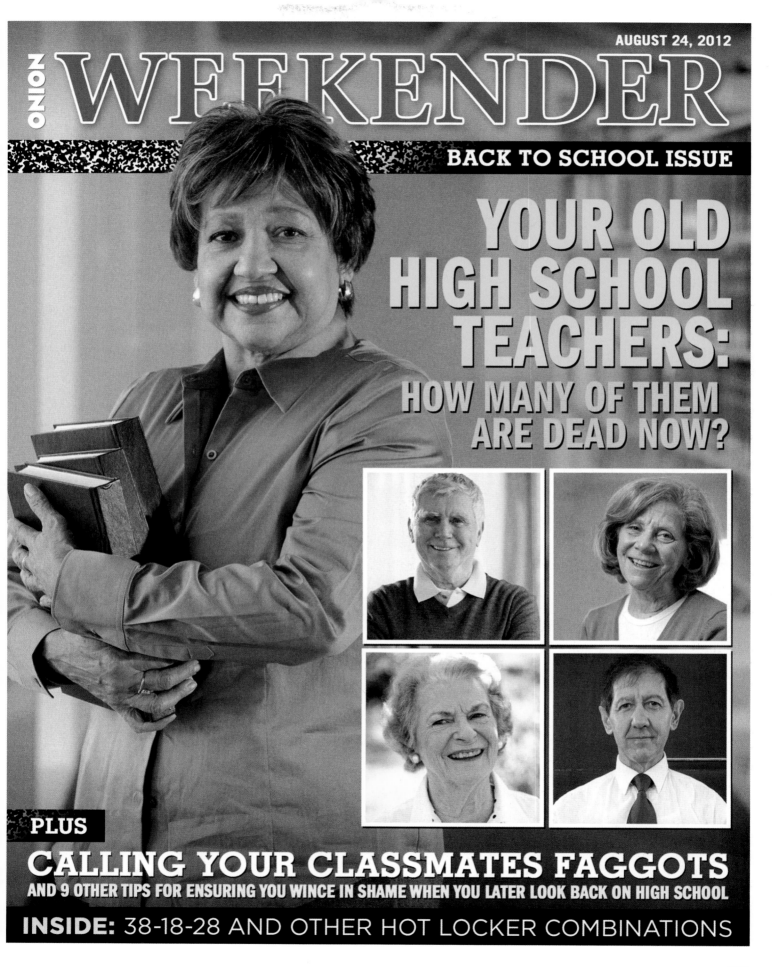

AUGUST 24, 2012

ONION WEEKENDER

BACK TO SCHOOL ISSUE

YOUR OLD HIGH SCHOOL TEACHERS:
HOW MANY OF THEM ARE DEAD NOW?

PLUS

CALLING YOUR CLASSMATES FAGGOTS
AND 9 OTHER TIPS FOR ENSURING YOU WINCE IN SHAME WHEN YOU LATER LOOK BACK ON HIGH SCHOOL

INSIDE: 38-18-28 AND OTHER HOT LOCKER COMBINATIONS

227

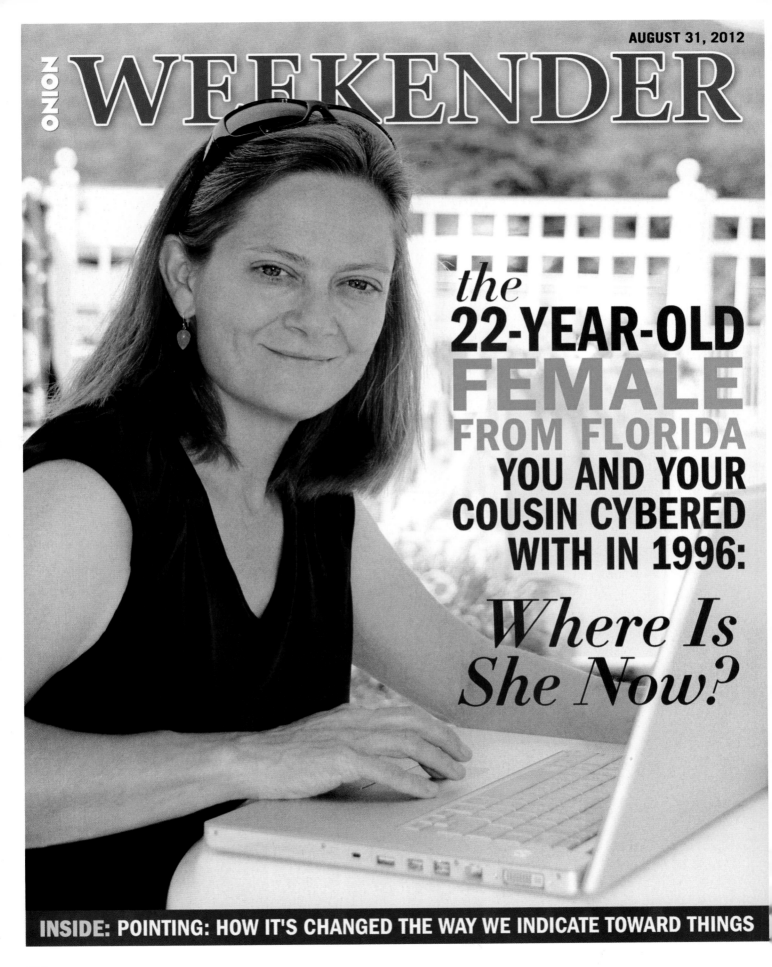

AUGUST 31, 2012

ONION WEEKENDER

the
22-YEAR-OLD
FEMALE
FROM FLORIDA
YOU AND YOUR
COUSIN CYBERED
WITH IN 1996:

Where Is She Now?

INSIDE: POINTING: HOW IT'S CHANGED THE WAY WE INDICATE TOWARD THINGS

$25

The Onion Magazine

THE PUPPIES OF 9/11

BECOMING FULL-GROWN DOGS IN THE SHADOW OF TERROR

$25

The Onion Magazine

IN TOUGH ECONOMIC TIMES THIS MAN HAD THE COURAGE TO START HIS OWN BUSINESS, WHICH THEN FAILED

ONION WEEKENDER

30,000
THINGS TO WANT

INSIDE: MAKE YOUR WHOLE FUCKING HOUSE SMELL LIKE CINNAMON

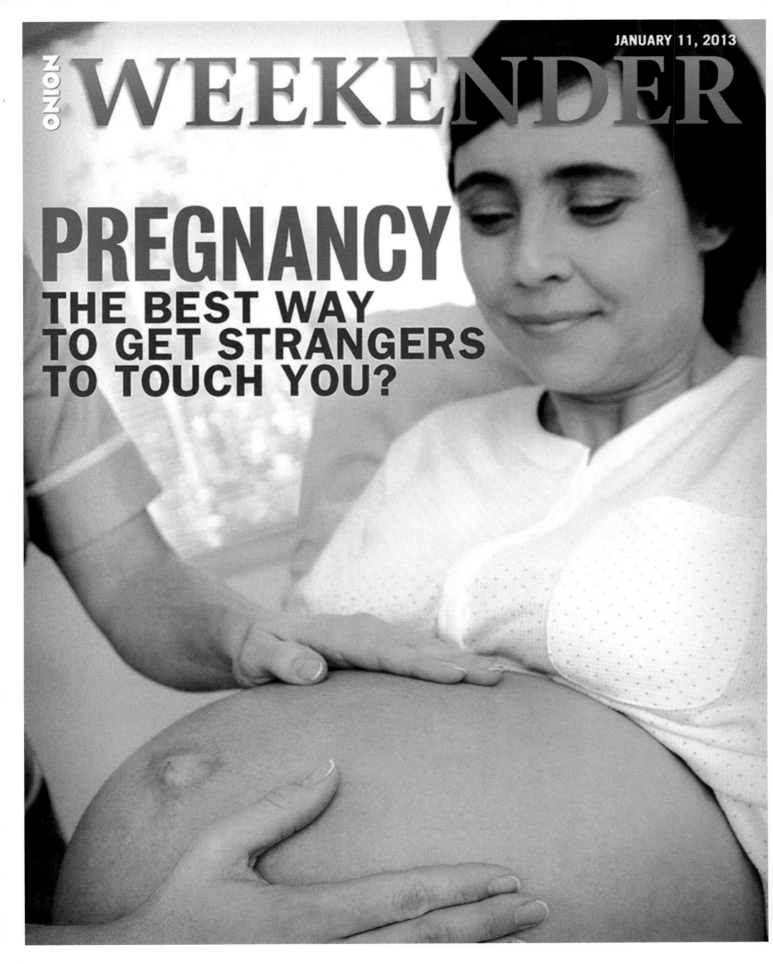

ONION

WEEKENDER

PREGNANCY
THE BEST WAY TO GET STRANGERS TO TOUCH YOU?

ONION WEEKENDER

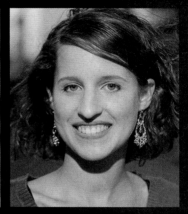
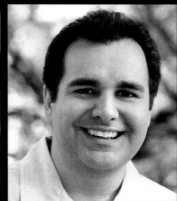

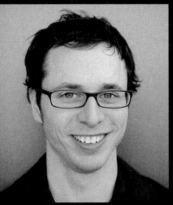

ARE YOU JEWISH?

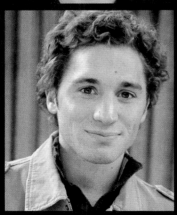

WE'RE UPDATING OUR ANNUAL LIST

INSIDE: 48 Sheets Of Construction Paper

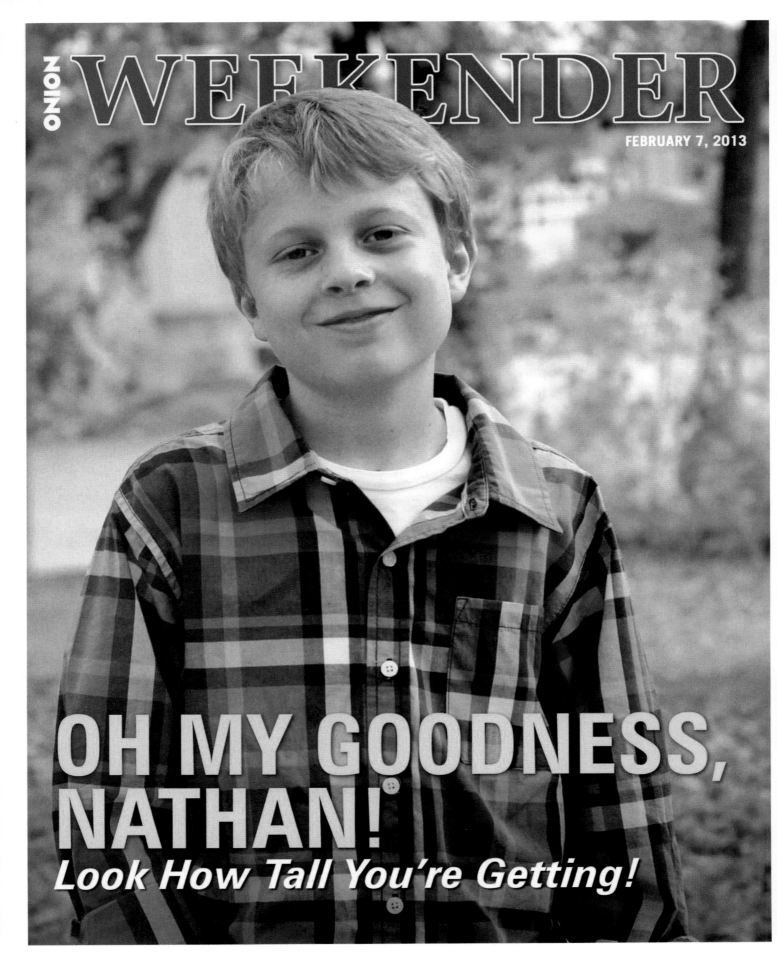

234

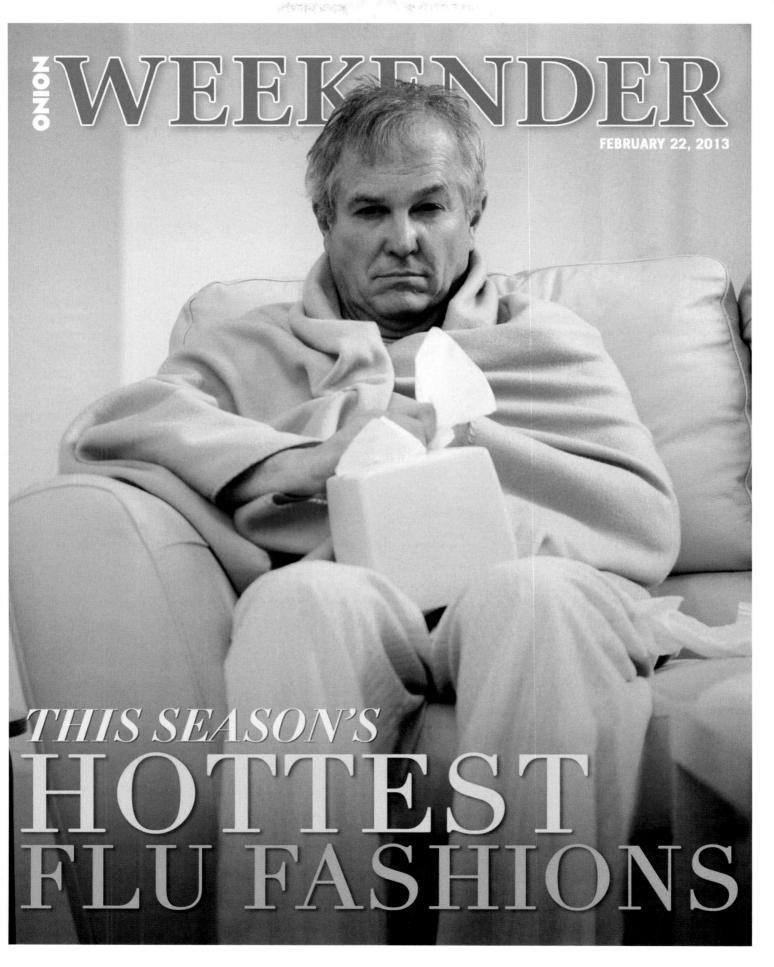

THE ONION WEEKENDER

FEBRUARY 22, 2013

THIS SEASON'S
HOTTEST
FLU FASHIONS

The Onion Magazine

MARCH 3, 2013

3 COOL LIGHTERS
WE FOUND AT OUR UNCLE'S HOUSE

By Chris Wagner

The Onion Magazine

MARCH 10, 2013

ASSASSINATING SHAMU

And 14 Other Embarrassing Failed Terrorist Plots

By James Cohen

ONION **WEEKENDER**

MARCH 13, 2013

AT WHAT AGE SHOULD YOU TALK TO YOUR KIDS?

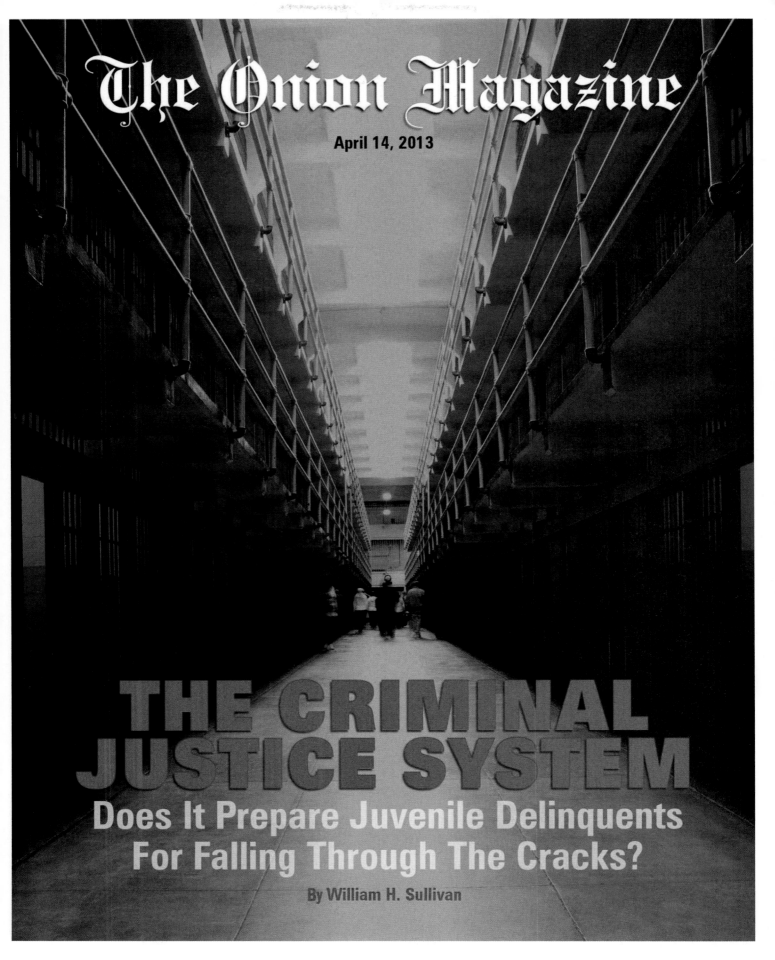

The Onion Magazine

April 14, 2013

THE CRIMINAL JUSTICE SYSTEM

Does It Prepare Juvenile Delinquents For Falling Through The Cracks?

By William H. Sullivan

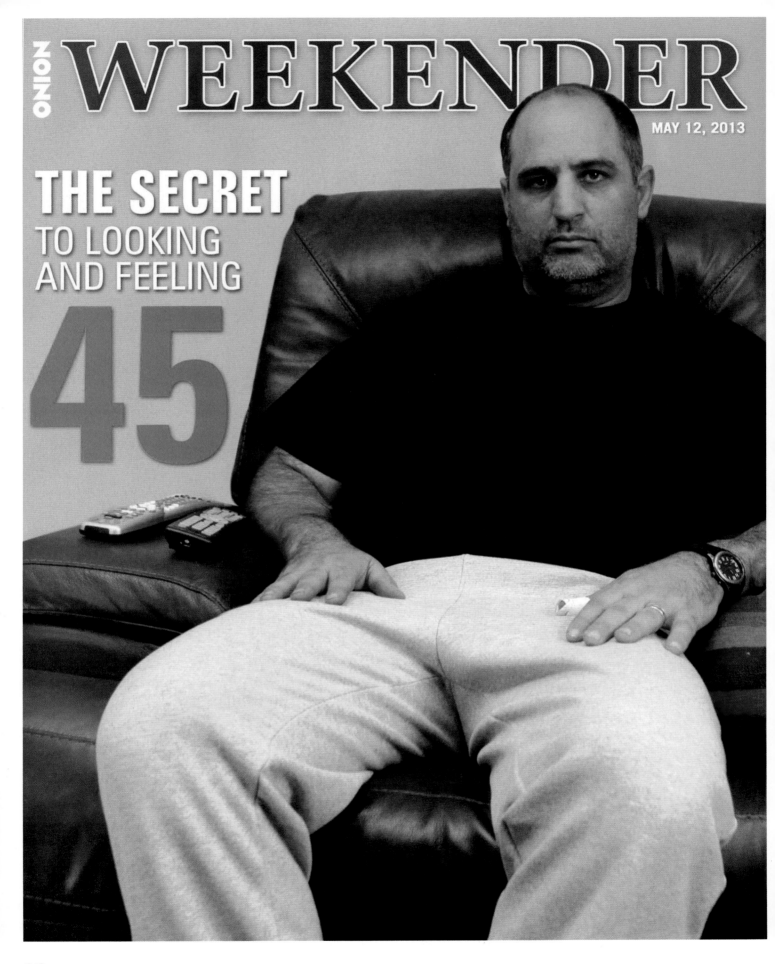

ONION **WEEKENDER**

MAY 19, 2013

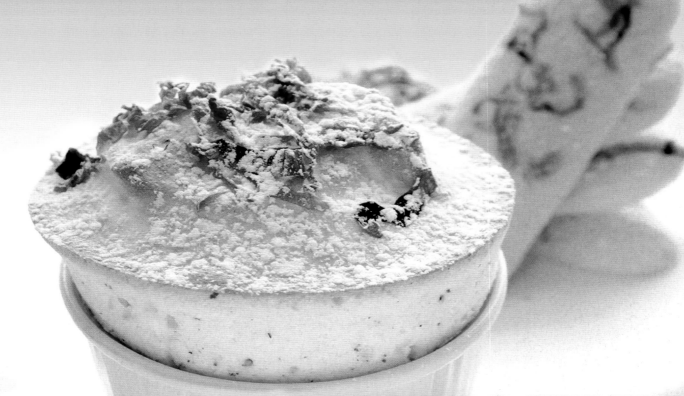

GETTING THAT
PERFECT SOUFFLÉ
IN A WORLD OF
UNCERTAINTY
AND PAIN

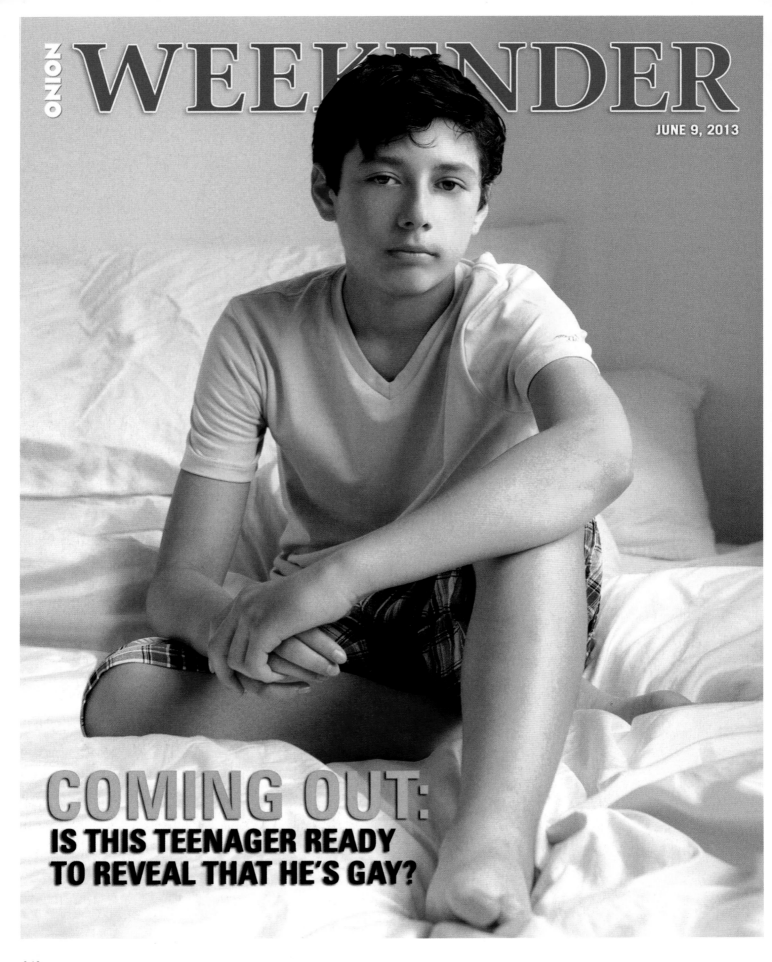

ONION **WEEKENDER**

JUNE 9, 2013

COMING OUT:
IS THIS TEENAGER READY
TO REVEAL THAT HE'S GAY?

ONION WEEKENDER

JUNE 16, 2013

0 FUN

WEEKEND GETAWAYS

The Onion Magazine

June 23, 2013

AUSTRALIAN ABORIGINE POP

WILL IT SURVIVE THE LOSS OF YOTHU YINDI FRONTMAN MANDAWUY YUNUPINGU?

By William Vaughn

ONION WEEKENDER

JULY 28, 2013

4 EXCITING NEW WAYS TO MAKE A PINEAPPLE

SEEM LIKE ANOTHER PERSON IN THE ROOM

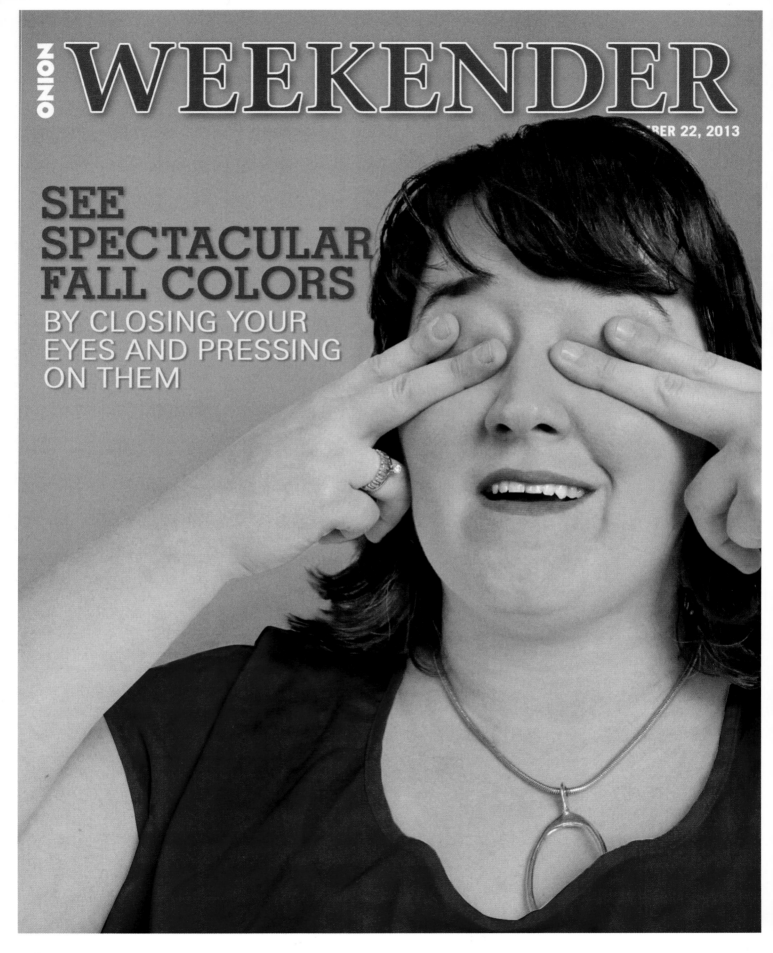

The Onion Magazine

SEPTEMBER 29, 2013

PRETTY BALLOONS

2006-2013

BY CLARA LINWOOD

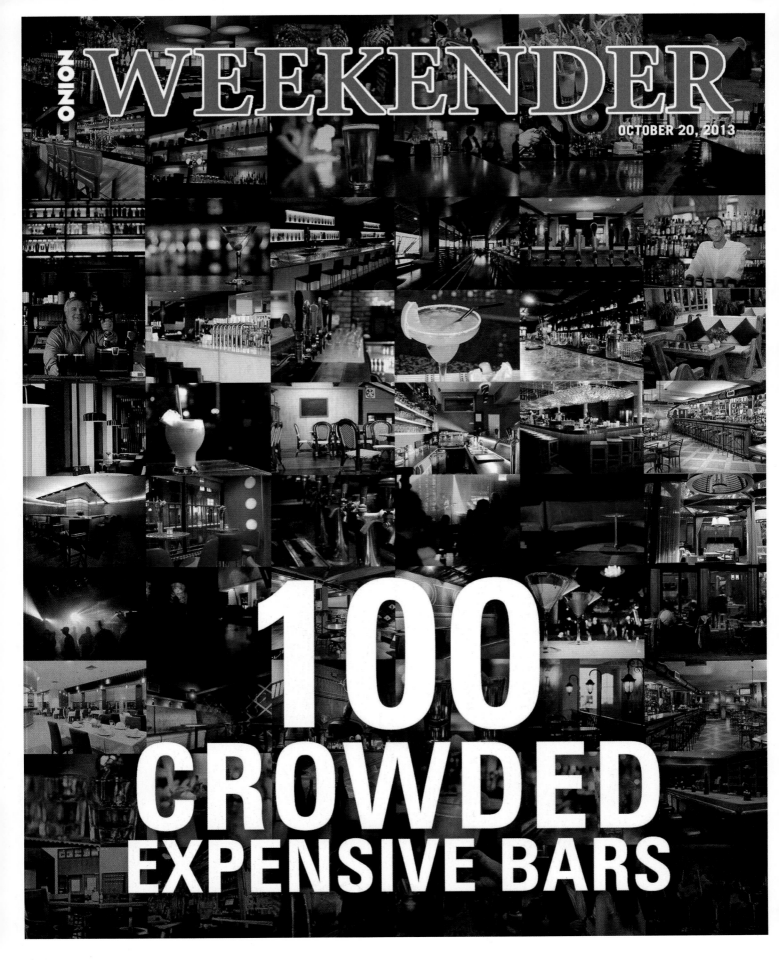

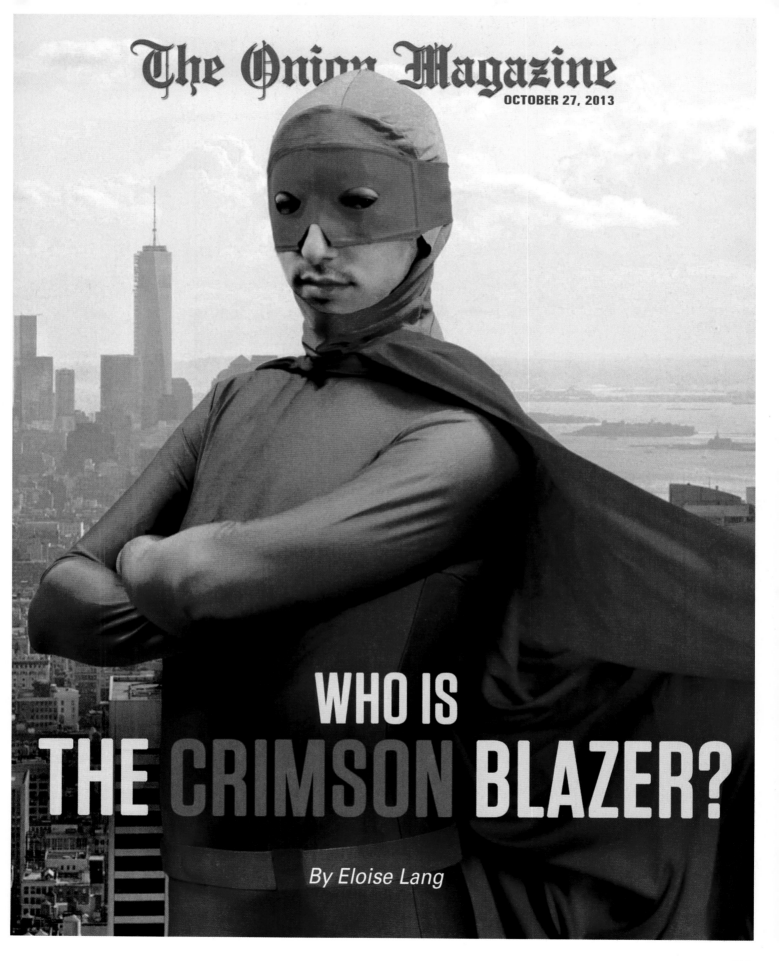

The Onion Magazine
OCTOBER 27, 2013

WHO IS
THE CRIMSON BLAZER?

By Eloise Lang

NOVEMBER 11, 2013

NECKERCHIEFS
The Story Of How They Never Became A $2 Billion-A-Year Industry

By Norman Walker

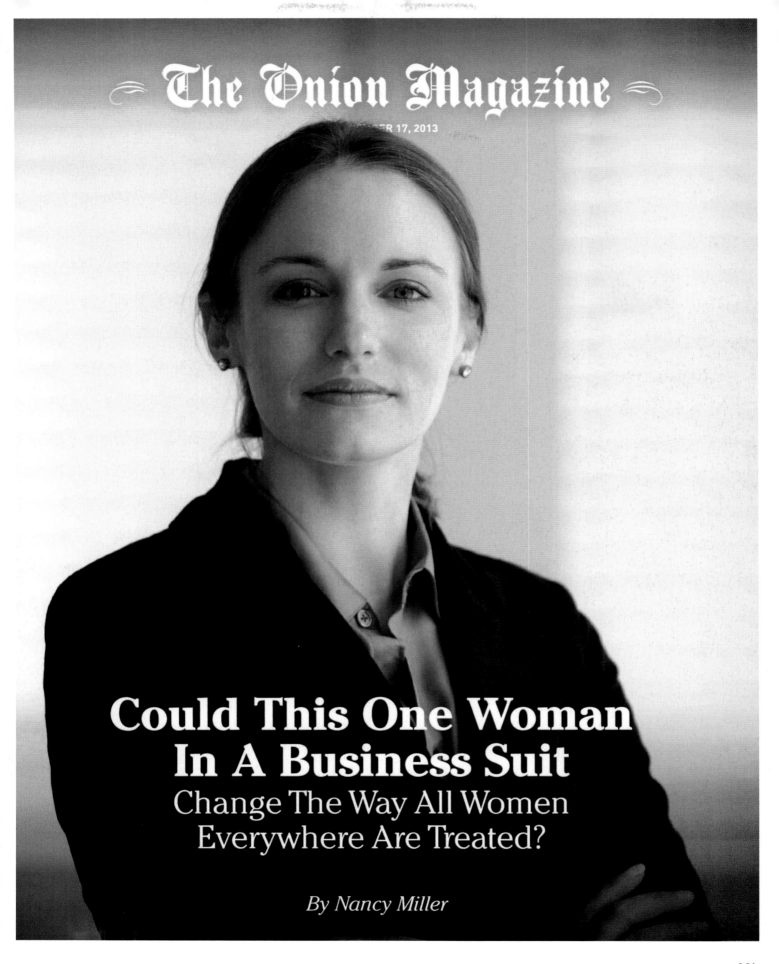

ER 17, 2013

Could This One Woman In A Business Suit

Change The Way All Women Everywhere Are Treated?

By Nancy Miller

ONION

WEEKENDER

JANUARY 19, 2014

REGAINING YOUR
PREGNANCY
WEIGHT
AND KEEPING IT ON FOR GOOD

INSIDE: WHICH GOOD THINGS ARE BAD NOW?

252

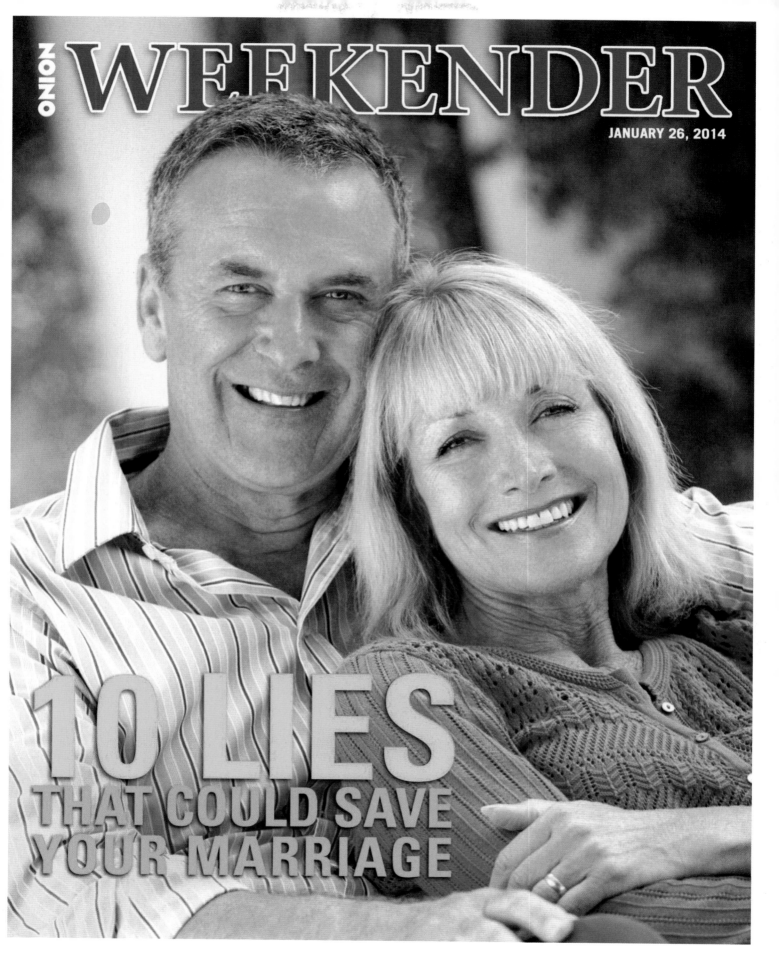

ONION WEEKENDER

JANUARY 26, 2014

10 LIES
THAT COULD SAVE
YOUR MARRIAGE

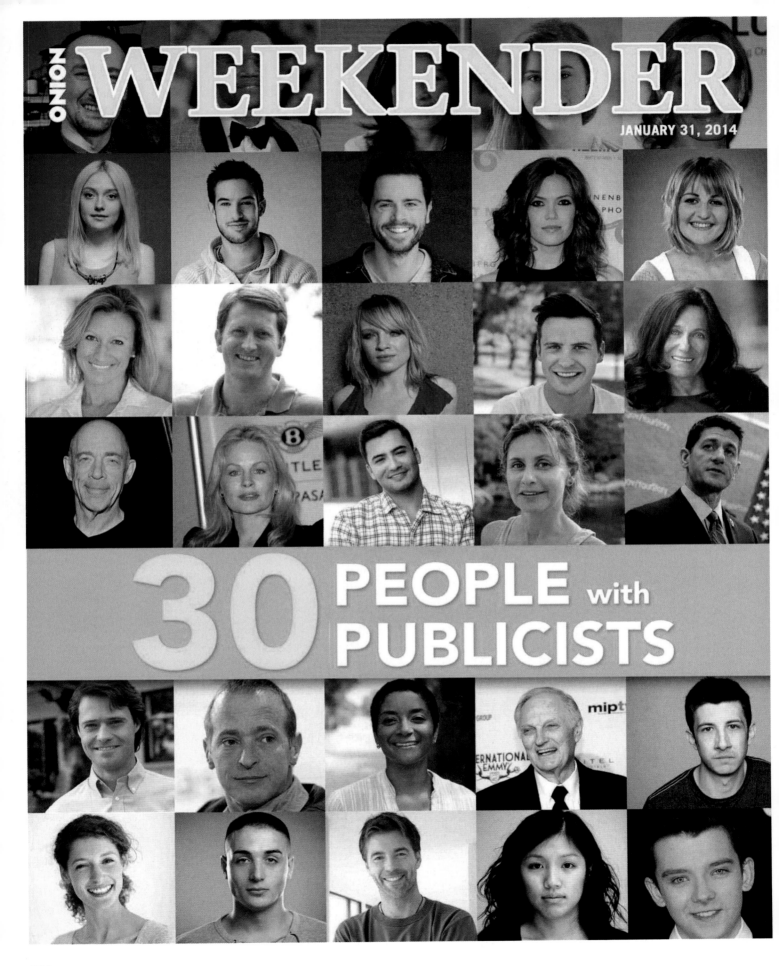

ONION WEEKENDER

JANUARY 31, 2014

30 PEOPLE with PUBLICISTS

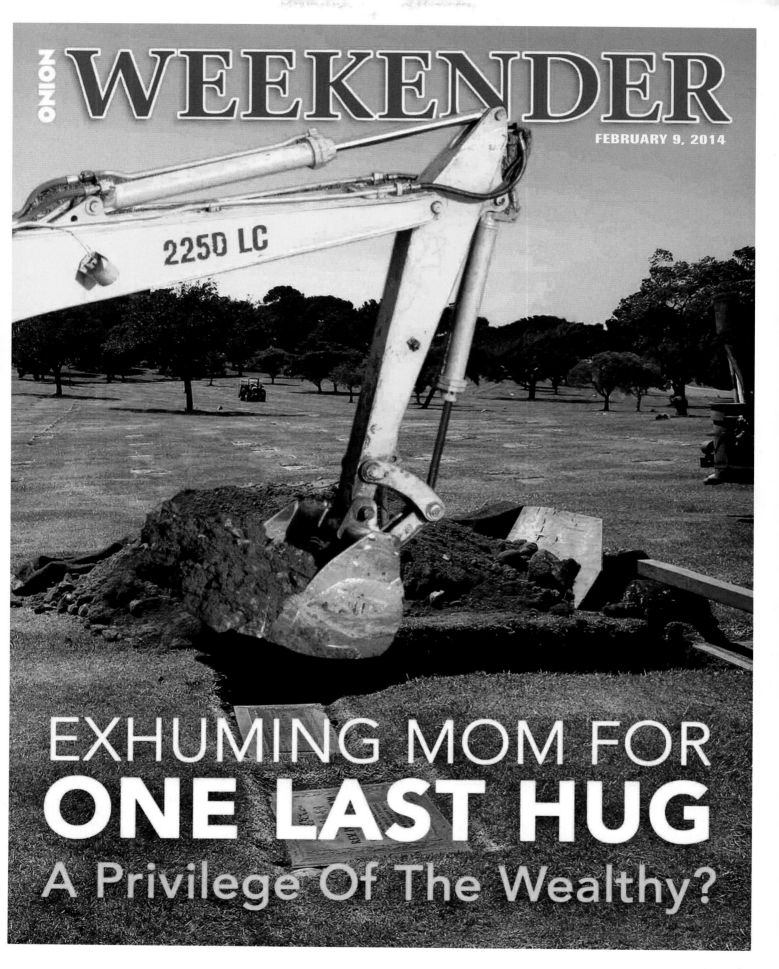

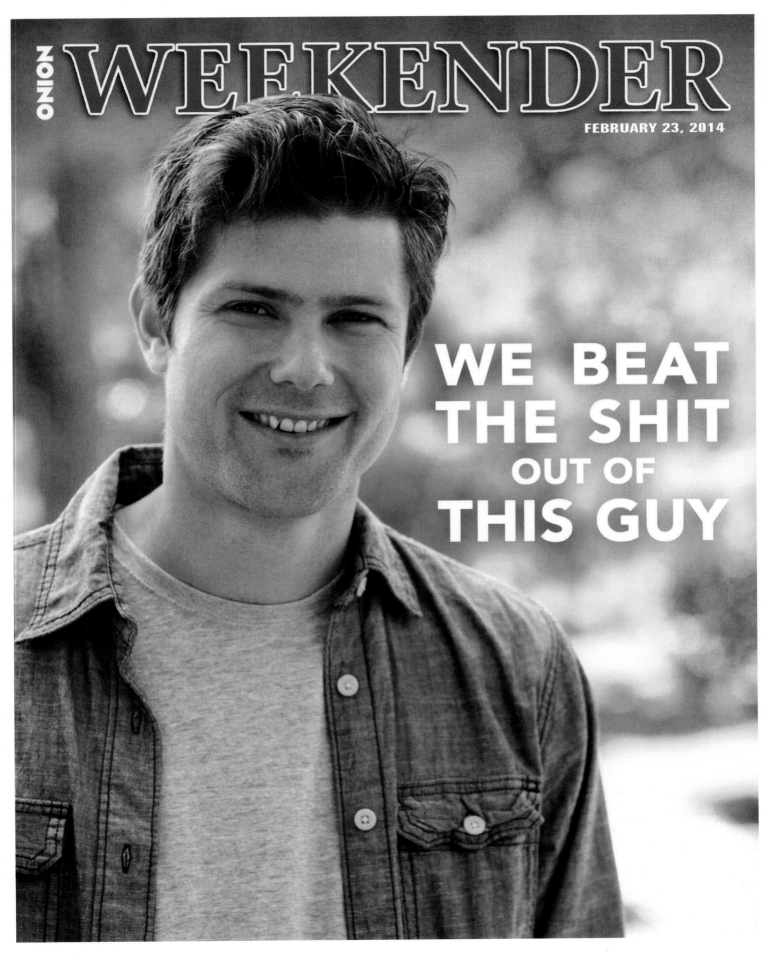

ONION WEEKENDER

MARCH 16, 2014

WHERE IS GOD HIDING?

ONION

WEEKENDER

MARCH 30, 2014

HORSEY!

258

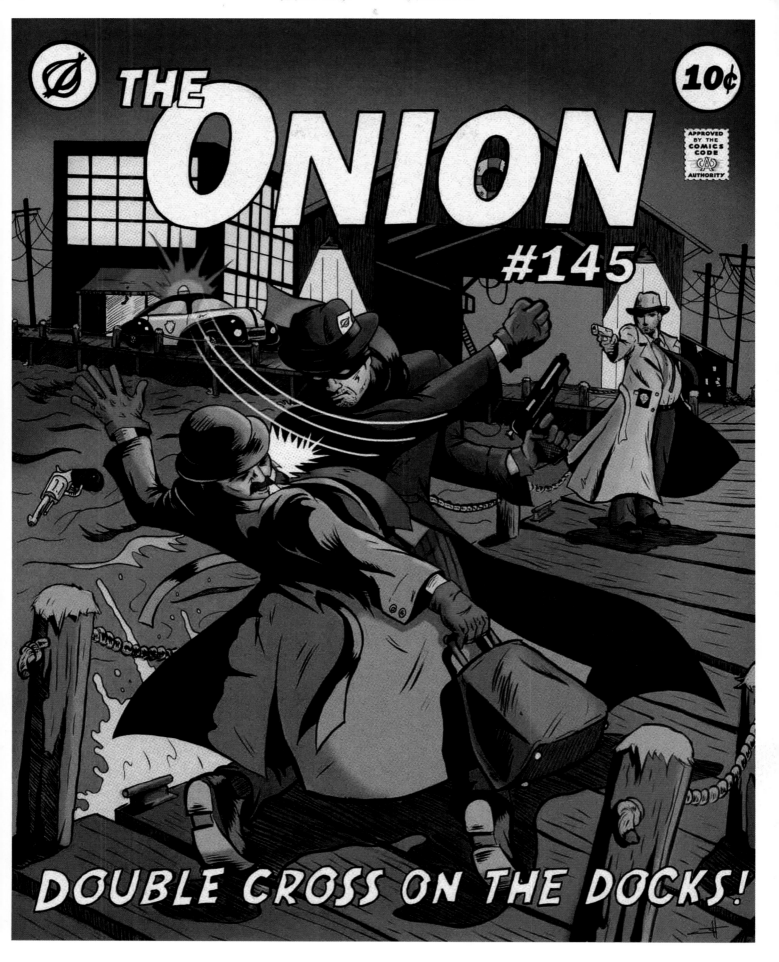

ONION

WEEKENDER

JUNE 1, 2014

'I Thought He Was Going To Kill Me':

ONE WOMAN'S HARROWING MISUNDERSTANDING OF HOW HAIRCUTS WORK

THE BEATLES OR BLUES TRAVELER: *The Debate Continues*

ACKNOWLEDGMENTS

Special thanks to Daniel Greenberg; Malin von Euler-Hogan and her colleagues at Little, Brown: Allie Sommer, Lauren Harms, Heather Fain, Mario Pulice, Rebecca Westall, Kate MacAloney, Catherine Cullen, Mary Tondorf-Dick, Michael Pietsch, and Reagan Arthur; Geoff Shandler; Loretta Donelan, Fran Hoepfner, Sunny Kang, Michelle Spies; Johannes Gutenberg; Chet Clem; Kate Palmer; Dave Kornfeld; Brian Janosch; Danny Mulligan; David Schafer; Steve Hannah; Mike McAvoy; all of our dedicated colleagues, past and present, at Onion, Inc.

GRAPHICS CREDITS

G=Getty Images; O=Onion Graphics; P=Photos.com; PD=Public Domain

vii-PD; Page 1-G; Page 2-G; Page 3-O; Page 4-G; Page 5-G; Page 6-G; Page 7-G; Page 8-G; Page 9-G; Page 10-PD; Page 11-O; Page 12-G; Page 13-G; Page 14-O; Page 15-G; Page 16-G; Page 17-O; Page 18-G; Page 19-G; Page 20-G; Page 21-G; Page 22-G; Page 23-O; Page 24-G; Page 25-PD; Page 26-G; Page 27-G; Page 28-G; Page 29-G; Page 30-G; Page 31-O; Page 32-PD; Page 33-G; Page 34-G; Page 35-O; Page 36-G; Page 37-G; Page 38-G; Page 39-G; Page 40-O; Page 41-G; Page 42-G; Page 43-G; Page 44-G; Page 45-G; Page 46-G; Page 47-G; Page 48-O; Page 49-G; Page 50-G; Page 51-G; Page 52-PD; Page 53-G; Page 54-O; Page 55-O; Page 56-G; Page 57-G; Page 58-G; Page 59-G; Page 60-PD; Page 61-O; Page 62-G; Page 63-O; Page 64-O; Page 65-G; Page 66-G; Page 67-O; Page 68-G; Page 69-G; Page 70-G; Page 71-G; Page 72-O; Page 73-O; Page 74-G; Page 75-O; Page 76-G; Page 77-G; Page 78-G; Page 79-O; Page 80-G; Page 81-G; Page 82-G; Page 83-G; Page 84-G; Page 85-G; Page 86-G; Page 87-G; Page 88-G; Page 89-G; Page 90-O; Page 91-G; Page 92-G; Page 93-O; Page 94-G; Page 95-G; Page 96-PD; Page 97-O; Page 98-O; Page 99-O; Page 100-G; Page 101-G; Page 102-G; Page 103-G; Page 104-O; Page 105-G; Page 106-G; Page 107-G; Page 108-O; Page 109-G; Page 110-G; Page 111-G; Page 112-G; Page 113-G; Page 114-G; Page 115-G; Page 116-O; Page 117-O; Page 118-G; Page 119-G; Page 120-G; Page 121-O; Page 122-G; Page 123-G; Page 124-G; Page 125-G; Page 126-G; Page 127-G; Page 128-G; Page 129-G; Page 130-G; Page 131-G; Page 132-G; Page 133-G; Page 134-G; Page 135-O; Page 136-G; Page 137-G; Page 138-G; Page 139-G; Page 140-O; Page 141-G; Page 142-O; Page 143-G; Page 144-G; Page 145-G; Page 146-G; Page 147-G; Page 148-O; Page 149-O; Page 150-O; Page 151-G; Page 152-G; Page 153-G; Page 154-G; Page 155-G; Page 156-G; Page 157-O; Page 158-O; Page 159-O; Page 160-G; Page 161-G; Page 162-G; Page 163-O; Page 164-G; Page 165-G; Page 166-G; Page 167-O; Page 168-G; Page 169-O; Page 170-G; Page 171-O; Page 172-G; Page 173-G; Page 174-G; Page 175-O; Page 176-G; Page 177-G; Page 178-G; Page 179-G; Page 180-G; Page 181-G; Page 182-G; Page 183-O; Page 184-G; Page 185-O; Page 186-G; Page 187-G; Page 188-G; Page 189-G; Page 190-O; Page 191-G; Page 192-G; Page 193-G; Page 194-G; Page 195-O; Page 196-O (Faisca); Page 197-O; Page 198-G; Page 199-G; Page 200-G; Page 201-G; Page 202-G; Page 203-G; Page 204-G; Page 205-G; Page 206-G; Page 207-G; Page 208-G; Page 209-G; Page 210-G; Page 211-G; Page 212-G; Page 213-G; Page 214-G; Page 215-G; Page 216-O; Page 217-G; Page 218-G; Page 219-G Page 220-G; Page 221-O (Grasso); Page 222-PD; Page 223-G; Page 224-G; Page 225-O (Nellis); Page 226-G; Page 227-G; Page 228-G; Page 229-G; Page 230-G; Page 231-G; Page 232-G; Page 233-G; Page 234-G; Page 235-G; Page 236-O; Page 237-G; Page 238-G; Page 239-G; Page 240-O; Page 241-O; Page 242-G; Page 243-G; Page 244-G; Page 245-G/O; Page 246-O; Page 247-G; Page 248-O; Page 249-O (Hasse); Page 250-O (Nellis); Page 251-G; Page 252-G; Page 253-G; Page 254-G; Page 255-G; Page 256-G; Page 257-G; Page 258-G; Page 259-O (Hasse); Page 260-G; Page 261-G